de Young

Selected Works

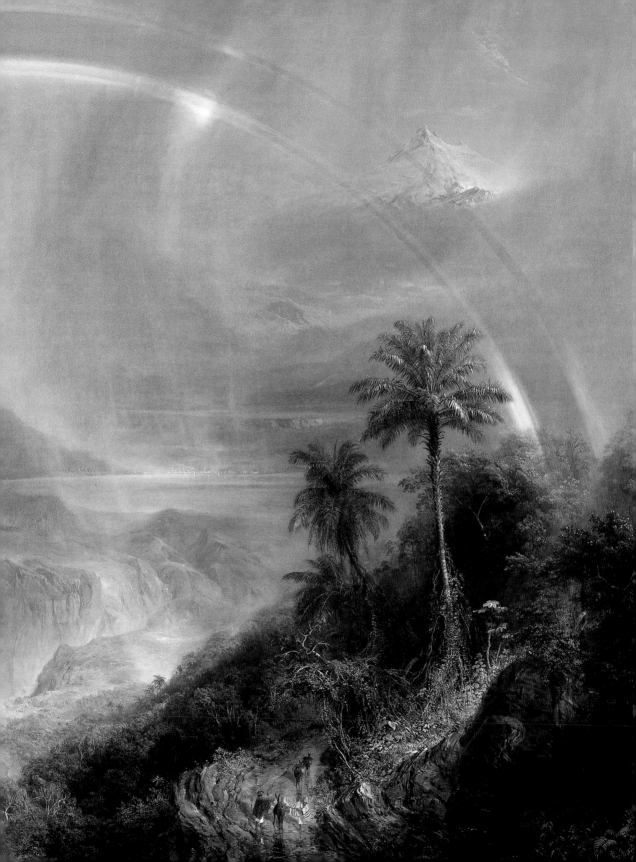

de Young

Selected Works

Renée Dreyfus

Fine Arts Museums of San Francisco

SCALA

Contents

Foreword

The de Young's collection has experienced great changes since the birth of the museum as the Fine Arts Building in the California Midwinter International Exposition of 1894. Throughout these years the museum has remained an important center for culture and art. The opening of the new de Young in Golden Gate Park, in the remarkable building designed by the architectural firm Herzog & de Meuron, signaled a time for an overview of the collections now housed and exhibited here. The galleries of art in America display a survey anchored by the Rockefeller gift that now stands among the most important collections of American painting in the country. The art from Africa, Oceania, and the Americas dramatically illustrates the expansion in these areas, and the space devoted to textiles reveals the growth and the broad range of that collection. New directions in collecting are visible in all areas, and perhaps most notably in contemporary art and sculpture, displayed in both the galleries and the sculpture garden.

The Fine Arts Museums are grateful for generous funding from the Ednah Root Foundation, which has made this publication possible. Renée Dreyfus, Curator of Ancient Art and Interpretation, graciously added to her many duties the writing of this publication, and she was ably assisted in the task by Louise Chu, Assistant Curator in her department. We are also grateful for invaluable input from the curators—Kathleen Berrin and Jennifer Williams Moore, Africa, Oceania, and the Americas; Timothy Anglin Burgard and Daniell Cornell, American Art; Robert Flynn Johnson and Karin Breuer, Achenbach Foundation for Graphic Arts; Diane Mott and Jill D'Alessandro, Textiles. Additional information was drawn from the Fine Arts Museums' *100 Years in Golden Gate Park*, edited by Pamela Forbes. The Museums' Managing Editor Elisa Urbanelli and Ann Karlstrom, Director of Publications and Graphic Design, as well as editor Audrey Walen, designer Pooja Bakri, and our co-publisher Scala Publishers (production director Tim Clarke and editorial director Oliver Craske) all added their skills to produce this lovely reminder of the beautiful and varied collection in Golden Gate Park. Our wish is that visitors will find in these pages reason to return again and again to enjoy both the familiar and the new.

Harry S. Parker III
Director of Museums

The Museum in the Park

A striking, copper-clad building designed by the Swiss architects Herzog & de Meuron, the de Young museum is home to one of the most diverse and significant art collections in the western United States. It is particularly renowned for its holdings in American art of all periods, including painting, sculpture, decorative arts, and works on paper; the art of Africa, Oceania, and the Americas; and costumes and textiles representing Eastern and Western traditions.

The evolution of the de Young into this superb building and outstanding collection took more than a century. In 1892 a San Francisco sculptor named Douglas Tilden, on discovering the cultural wonders of Paris, wrote:

> California is today not much of a patron of art. She is still unripe for a spontaneous interest in the beautiful. The high noon of culture and repose has not yet come. No public museum of fine arts exists in San Francisco. California is young, and does not understand art.

After seeing the Luxembourg Gardens with its own museum, he had a grand notion in mind for a museum in his provincial hometown:

> A visit to a museum generally has pleasure for its motive, and pleasure-seeking is inseparable from an afternoon jaunt among flowers and trees; therefore the museum should rather be in a park than elsewhere.

The park was Golden Gate Park, and the museum was to become the de Young.

Michael de Young, editor and proprietor of the *San Francisco Chronicle*, was one of the 27 million visitors to Chicago's World's Columbian Exposition of 1893, one of many great international expositions presented by cities such as Paris, London, Philadelphia, and Chicago in the nineteenth century. Although these world's fairs were usually planned as commercial ventures, their more lasting effects were often cultural. De Young, a powerful and colorful figure, attended in his official capacity as Columbian Commissioner from California and Vice President of the National Columbian Commission. Observing the spectacular success of the Chicago exposition, de Young conceived the idea of organizing another fair, which would take place in San Francisco, the Queen City of the Pacific. Writing a check for $5,000 to get private subscriptions underway, he set out to showcase the strength and diversity of California's economy, which was flourishing despite the financial depression of the time. On 27 January 1894 Mrs. M. H. de Young pushed a button that "set the machinery in motion" and launched the California Midwinter International Exposition in San Francisco. Opening day attendance was 72,248, and the event that was thought impossible to stage without years of preparation was off to a rousing success. By the closing date on 4 July 1894, the fair's total attendance was 1,315, 022—and it made a profit.

To avoid comparison with the classically inspired Chicago exposition, the San Francisco fair's commissioners encouraged the unconventional. The result was a group of pavilions in a range of styles, including Moorish, Indian, Romanesque, Oriental, and Old Mission. The Fine Arts Building, designed by the San Francisco architect Charles C. McDougall, was a fanciful Egyptian Revival building complete with a pyramid at its roof, massive entrance columns with heads of Hathor—the Egyptian cow goddess—at their tops, and sphinxes flanking the approach to the doorway. It was the only fair building erected to standards of permanent construction and, at de Young's urging, after the fair closed it was retained to become the Memorial Museum, commemorating the exposition.

The Midwinter Exposition had brought to San Francisco scientific, historic, and artistic treasures. The funds it generated were used to purchase many of the exhibits, which filled the new museum with "treasures and curios for the entertainment and instruction of the people of California." These acquisitions thus became the charter collection of the de Young, and many of them have been enjoyed by generations of museum visitors. The *Chronicle*'s advance story boasted that the museum's "collection of birds and eggs is one of the most complete ever made. It includes 23,000 stuffed birds, and eggs of every biped that ever had wings."

The first curator, Charles P. Wilcomb, organized the original displays, which were augmented by "curios" purchased in Europe by de Young, reflecting his eclectic taste. The new museum featured paintings, sculpture, and fine porcelain, but also a forestry exhibit, "soil, cereals, nuts and fruits," and "relics" from Alaska, the South Sea Islands, Native American cultures, and ancient Mediterranean centers, including original art as well as reproductions. It also contained twenty

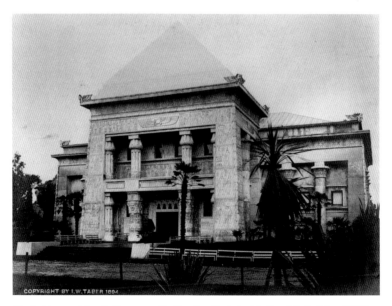

The first home of the de Young was the Egyptian Revival–style Fine Arts Building (1894), designed by Charles C. McDougall for the California Midwinter International Exposition.
Photograph by Isaiah West Taber, 1894

complete suits of armor, forging and castings from the Middle Ages, antique furniture, Greek pottery, a Napoleonic room, a jewel hall, and an Egyptian mummy "of a princess." The popular natural history section included local donations such as "snakes in alcohol."

Damage caused by the 1906 earthquake that devastated San Francisco forced the museum to close for over a year for repairs. The completion of the Panama Canal in 1914 gave San Francisco an excuse for another international exposition to show the world the newly rebuilt city. Undaunted by the outbreak of World War I, the Panama Pacific International Exposition (PPIE) opened in 1915. De Young was once again appointed director. Meanwhile, after twenty years, the museum's need for more space had become urgent. The collections were growing rapidly, and every gallery was filled to overflowing. De Young commissioned architect Louis C. Mullgardt, whose work at the PPIE was a highlight of the fair, to plan a museum addition. Designed to evoke the sixteenth-century Spanish Renaissance style, which had been used at the PPIE, a spacious building with a tower and a central courtyard was constructed adjacent to the original museum. Funded from private donors and de Young's own savings, it was completed in two stages, in 1919 and 1921. At the time of the 1921 opening, the museum's attendance equaled that of New York's Metropolitan Museum and surpassed that of the Smithsonian Institution; the collection was said to contain 1 million objects.

To honor de Young's great efforts, in 1924 his name was added to the museum's by a city charter amendment, and the M. H. de Young Memorial Museum was inaugurated. He died the following year. In 1929 the original Egyptian Revival building was demolished, and two years later another new wing opened to the public. The museum continued to grow both in collections and in the space needed for storage and display.

As early as 1928 many of the stuffed birds and other natural history objects were considered unfit for exhibition, leading to the museum's shift toward specializing in art. In 1930 this

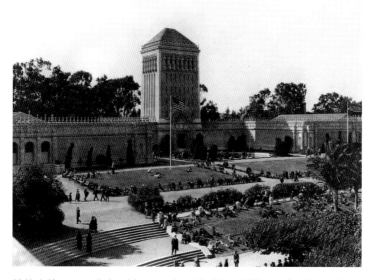

M. H. de Young commissioned the expansion of the Memorial Museum from the architect Louis C. Mullgardt. Completed in two phases, in 1919 and 1921, it was designed in a style derived from sixteenth-century Spanish architecture.

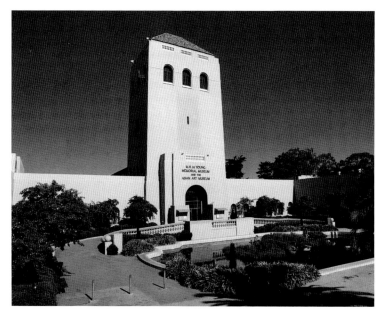

The M. H. de Young Memorial Museum as it looked after 1949, when the concrete ornament was removed from the exterior. Photograph by Joseph McDonald

movement was given great impetus when Samuel H. Kress gave the museum two Italian Renaissance paintings, the first of many valuable gifts he presented to the de Young over the years.

The Great Depression ended the museum's expansive projects. Yet the de Young continued to display a growing permanent collection supplemented by outstanding temporary exhibitions. In 1932, for example, the museum held the famous *Group f.64* show of photographers, including Edward Weston, Ansel Adams, and Imogen Cunningham. At a time when the art of America was not widely valued, the museum installed an exhibition of more than 400 American paintings, which ultimately led the way to the de Young's later emphasis in this area. In his foreword to the catalogue, Walter Heil, who became the museum's director in 1933, wrote that the exhibition had been "planned to give the people of San Francisco a clear and comprehensive idea of the art of painting in our country from its beginnings to the present day." Under his direction the institution was transformed into an art museum.

Another great San Francisco fair, the Golden Gate International Exposition, took place in 1939 and 1940. Walter Heil organized its display of European masterpieces, exhibiting Botticelli's *Birth of Venus* along with works by Géricault, Manet, and Renoir, among other greats. The American section included Thomas Hart Benton's scandalous *Susanna and the Elders* (page 96), which was given to the museum after the fair closed by an anonymous donor who hoped the painting would "shock people and stir up conversation and get people going to the museum."

The lean years of the depression and World War II took their toll on the building—for example, the deteriorating concrete ornament, considered a hazard, was eventually stripped from the exterior in 1949—but with peace came long-delayed improvements and the display of new art. Ninfa Valvo, the museum's curator of painting and sculpture, had an astute eye for modern art. She gave artists such as Elmer Bischoff and David Park their first museum exposure.

The public, however, still had a taste for the timeless art of the past, and exhibitions of works by El Greco and *Masterpieces of the Berlin Museums* proved popular in the postwar years. In the late 1940s San Francisco philanthropists Roscoe and Margaret Oakes, a couple who considered the de Young their second home, purchased many superb works of European art to fill gaps in the collection.

Throughout the 1950s and 1960s the museum mounted all types of exhibitions. One-person shows featured artists such as Richard Diebenkorn, Frank Lobdell, and Wayne Thiebaud, whose works are now in the permanent collection. Group shows were also popular.

In 1969 the board of trustees of the de Young invited Ian McKibbin White, director of San Francisco's California Palace of the Legion of Honor, to act as director of the de Young during its major van Gogh exhibition. He was appointed head of both institutions in 1970, and a city charter amendment in 1972 officially combined the two museums under a single administration. The new institution was named the Fine Arts Museums of San Francisco—the largest public arts institution in San Francisco and one of the largest art museums in America. Under Ian White's direction, departments were established for ancient art; textiles; the art of Africa, Oceania, and the Americas (known as AOA); and American painting and decorative arts. Conservation laboratories were set up for textiles, objects, and works on paper. It was the beginning of the age of block-buster exhibitions—the van Gogh show brought more than 400,000 visitors to the de Young in five weeks, but the all-time record-breaker was *Treasures of Tutankhamun* in 1979, with more than 1.8 million visitors.

Many generous patrons have contributed to the de Young's world-class holdings. In particular, the American collection contains many masterworks given to the museum by Mr. and Mrs. John D. Rockefeller 3rd, which made the de Young the finest collection of American art on the West Coast. Another outstanding benefactor, Phyllis Wattis, donated gifts that spread across many areas of the museum. Chief among them was the donation that made possible the acquisition of the Crown Point Press Archive, with its more than 3,000 works from one of the top printmaking workshops in the country. Always a supporter of the museum's AOA department, she made contributions that have helped to acquire many superb objects. Her endowment continues to add major works to the de Young.

Harry S. Parker III became Director of Museums in July 1987. With him came innovative concepts that were to energize the museums. He divided the combined collections so that the Legion focused entirely on antiquities and European art, as well as works of art on paper, allowing the de Young to display a greatly expanded presentation of art in America from colonial times, textiles, contemporary art, and the arts of Africa, Oceania, and the Americas.

The 1989 Loma Prieta earthquake set a new direction for the de Young. After sustaining extensive damage, the building was declared seismically unsound, and temporary steel bracing had to be added to the exterior so that the museum could remain open to the public. The old building was demolished in 2000. The new de Young, opened in 2005, doubles the exhibition space of the former museum. Its adventurous design provides dramatic galleries, an outdoor sculpture garden, and the twisting nine-story Education Tower, which offers spectacular views of the city from its observation floor.

The de Young is now assured a long and fruitful future. And M. H. de Young's investment in "things for the entertainment and instruction of the people of California" continues to provide for new generations of visitors to come to the museum in the park.

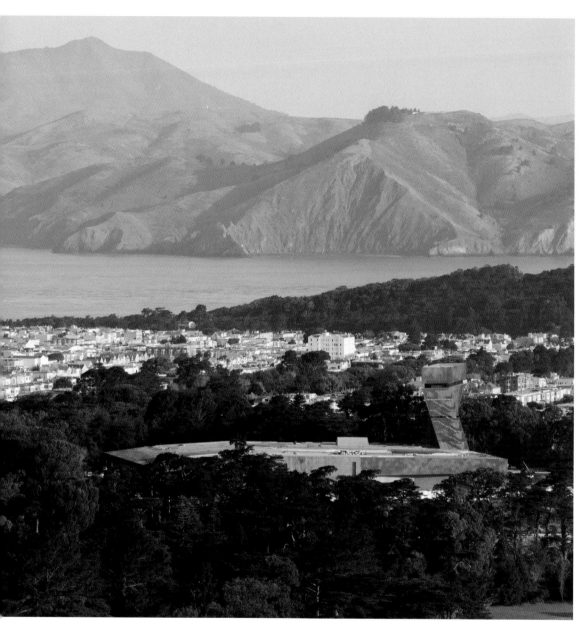

The de Young in Golden Gate Park, 2005.
Photograph by Mark Darley

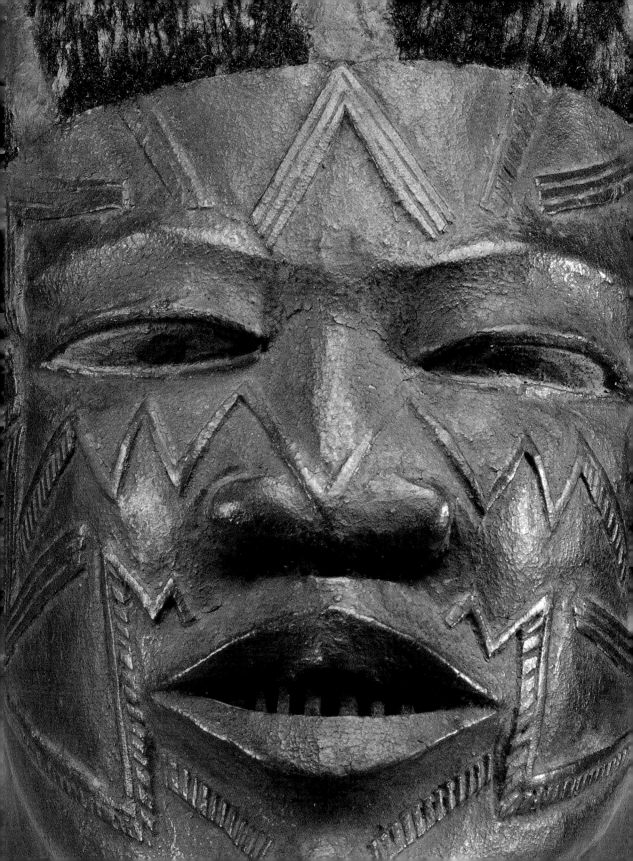

Art of Africa

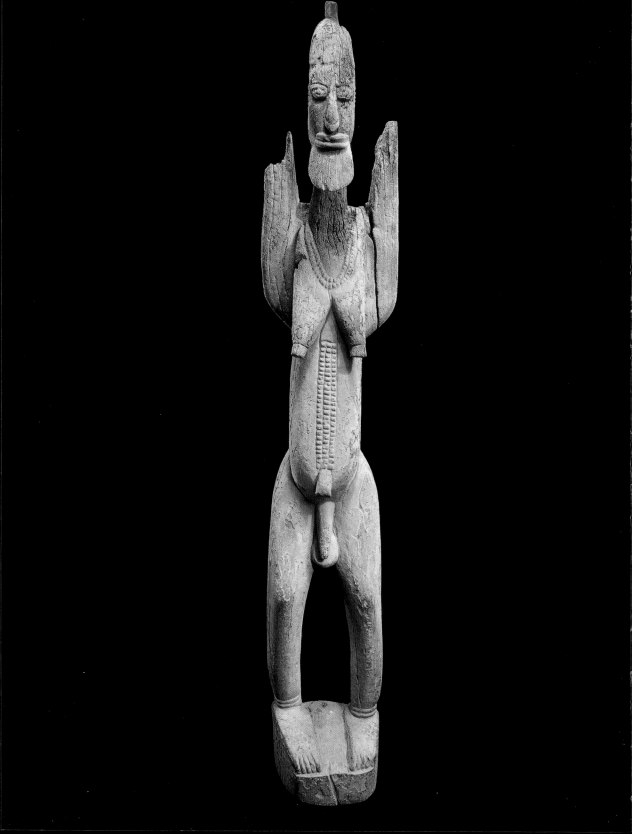

STANDING ANCESTOR OR DIVINITY

Dogon people, Mali, AD 1027–1209

Wood and metal with ritual patina
68 x 12 x 10 in. (172.7 x 30.5 x 25.4 cm)

Museum purchase, gift of the Wattis Family, in
loving memory of Phyllis Wattis, and Roscoe
and Margaret Oakes Income Fund
2003.65

This outstanding sculpture, one of the earliest known examples of Dogon carving, may have been created to represent a divinity or an ancestor of an ancient lineage. The figure is androgynous, containing both male and female characteristics, and is intended to be the visual representation of a concept, perhaps the Dogon cultural ideals of balance and duality in nature.

The figure was carved from a single piece of hardwood, which over time acquired a thick patina from repeated ritual treatments and applications intended to preserve the wood. The gesture of the upraised arms may signify a prayer to a supreme being or communication between the heavens and earth.

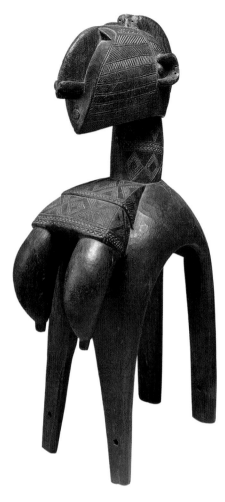

HEADDRESS (*NIMBA*)

Baga people, Guinea, early 20th century

Wood, 42 x 22 in. (106.7 x 55.9 cm)

Bequest of Erle Loran, Bequest of Clyta Loran,
Promised gift of Ruth Schorer Loran
L99.78.2

Nimba headdresses are probably the largest African masks known to the West, and are considered the most representative pieces of the ritual art of the Baga, a people who inhabit western Guinea. This headdress is a good example of the size of these masks, being over three feet in height and extremely heavy. The headdress was made from a single piece of hardwood, and it is likely that it was once blackened with smoke and varnished with palm oil to give it a bright patina. Its strongly profiled head sits on a long cylindrical neck, below which swells a large, oval-shaped chest with flat breasts (symbols of motherhood and fertility) that tapers into the four legs. Incised decorative bands embellish the face, neck, and chest.

The *nimba* masquerade was traditionally danced before the rainy season, at marriages or funerals, and in honor of special guests. During these dances, a large raffia costume attached to the mask hid the dancer's body.

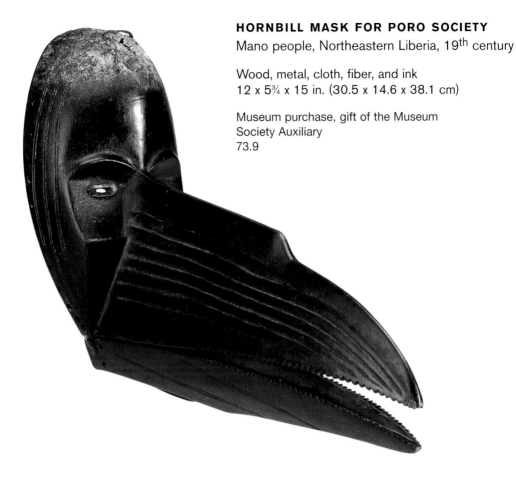

HORNBILL MASK FOR PORO SOCIETY
Mano people, Northeastern Liberia, 19th century

Wood, metal, cloth, fiber, and ink
12 x 5¾ x 15 in. (30.5 x 14.6 x 38.1 cm)

Museum purchase, gift of the Museum
Society Auxiliary
73.9

This mask, representing a hornbill bird with human features, is notable for its age and excellent carving, as well as for the archaic Arabic inscriptions of Koranic quotations, praise names, and magical squares on its inner surface. Islam mingled with the traditional animistic religions of the Mano people of Liberia and maintained a symbiotic relationship with the local culture. Among the Mano, masks always contained a direct link with founding ancestors and the spirit world. They were used to teach initiates or for social control.

The forehead is encrusted with dried blood, feathers, and chewed kola nut, and pieces of iron were driven into it. Along the edge of the mask are three rows of parallel lines and holes through which a costume was once attached.

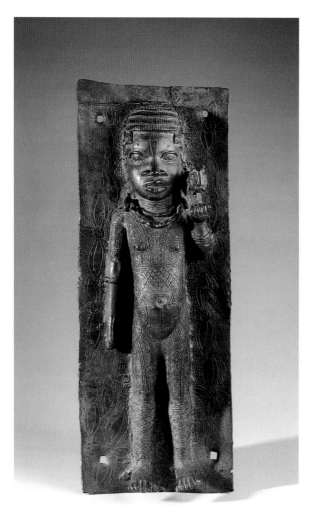

PLAQUE: GIRL WITH LEOPARD
Benin people, Kingdom of Benin,
Edo, Nigeria, ca. 1600

Bronze, 17¾ x 7 in. (45.1 x 17.8 cm)

Museum purchase, William H. Noble
Bequest Fund
1980.31

Of all the traditional forms of art from West Africa, bronze objects from the ancient kingdom of Benin are the best known and most coveted. This cast bronze representation of a young royal attendant to a Benin court is unique and enigmatic. It combines female anatomy with exclusively male attributes, such as the hairstyle and the three scarification marks over the eyes, as well as the association with a ritual water vessel in the form of a leopard, a preeminently royal emblem of power.

Commemorative in intent, Benin plaques are thought to depict past rulers and royal personages. This plaque is pierced at the four corners so that it could be attached to the wooden pillars of the royal palace of the Oba, the temporal and spiritual leader of Benin.

DIVINATION BOWL

Yoruba, Osogbo,
southwestern Nigeria,
early 20th century

Wood, 8¼ x 6½ x 5 in.
(21 x 16.5 x 12.7 cm)

Museum purchase,
Phyllis C. Wattis Fund
1984.5

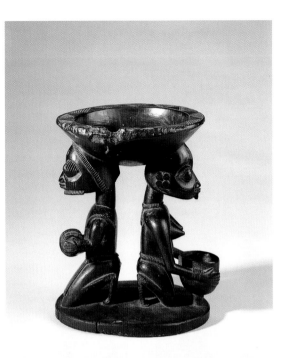

Carved from one piece of wood, this divination bowl rests on the heads of
two kneeling figures facing away from one another. The male holds a drum,
symbolic of his ritual responsibilities, while his wife carries a small bowl in her
elongated arms, suggesting fertility and abundance. Undoubtedly made by a
master carver, the work expresses the tension and balance of separate figures
connected by their task of carrying the bowl and by the similar and comple-
mentary nature of their poses. Among the Yoruba the most popular form
of divination is called *Ifa*. This bowl must have belonged to an Ifa priest who
kept sixteen sacred palm nuts in it. These nuts symbolize the supernatural
knowledge the priest could draw upon in a divination.

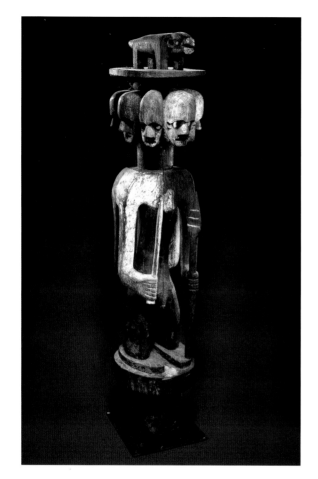

SHRINE FIGURE OF A SEVEN-HEADED BUSH SPIRIT

Ijo people, Niger River Delta, early 20th century

Wood, pigment, fiber, and glass
h. 68 in. (172.7 cm)

Museum purchase, gift of Phyllis C. Wattis and the Phyllis C. Wattis Fund for Major Acquisitions
2004.93

Made by the Ijo people of the Niger River Delta in the early twentieth century, this powerful and impressive shrine figure represents a bush spirit. Its two large bodies hold four weapons, while the figure's seven heads gaze vigilantly through eyes inlaid with mirrors. The use of mirrors might represent all-seeing power, the reflective surface of water, or access to the spirit world. This supernatural spirit probably stood inside a shrine where it protected a village from being invaded by enemies or hostile spirits, and perhaps even from disease. The shrine figure is painted with strongly contrasting colors: dark signifies strength, and the white denotes status as a titled member of a warrior society. The animal on top either depicts a leopard, symbolizing male power, or a dog, representing a spirit companion. The medicine bottle on the chest of the figure emphasizes male power.

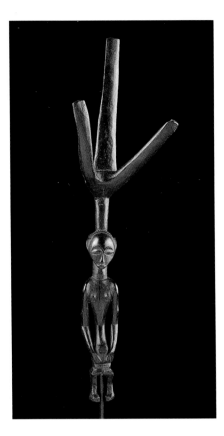
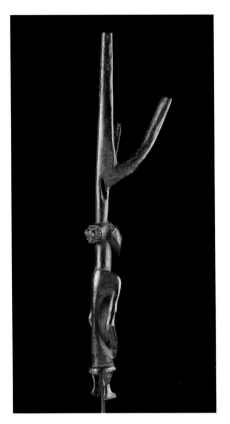

BOWSTAND

Luba/Hemba people, Democratic Republic of Congo (formerly Zaire), early 20th century

Wood and rock crystal
16⅛ x 4¾ x 3⁹⁄₁₆ in.
(41 x 12.1 x 91 cm)

Museum purchase, Unrestricted Art Endowment Fund, Diane and Chuck Frankel, Ruth and Marc Franklin, Ellen and Klaus Werner, Janine and Michael Heymann, Helen Land, A. Rebecca Snider and Riccardo Hahn, Anonymous, Dwight Strong, Gail and Alec Merriam, Eileen and James Ludwig, Marilyn and Ralph Spiegl, and Marc Felix
1991.13

Bowstands were part of a Luba chief's regalia, serving as receptacles or supports for his bow and arrows. This example is superbly carved, incorporating a female figure that may symbolize fertility and the continuity of the Luba people. The rock crystal embedded in the figure's coiffure is unusual and, as a symbol of the moon, suggests the owner of the stand was a member of a secret society that used phases of the moon to regulate its activities.

STANDING FIGURE

Lega people, eastern Zaire,
19th century

Wood and kaolin, 12 x 3¼ in.
(30.5 x 8.3 cm)

Museum purchase, gift of
Mrs. Paul L. Wattis and the Fine
Arts Museums Acquisition Fund
1986.16.5

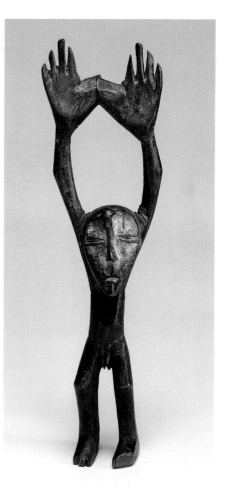

The raised arms, bald head, and toothless gums of this powerful and monumental figure identify it as an elder whose function is to arbitrate in community disputes and decisions. The interpretation of figures, however, changes in Lega art depending on context. When this standing figure was grouped with others in a basket filled with initiation objects, it could portray either a helpful or harmful elder. This dynamic symbol of the supreme arbiter was owned by initiates of the highest grade within the Bwami association. Such figures are connected with aphorisms, such as "What shoots up straight; I have arbitrated the sky; I have arbitrated something big." The finely polished wood is seen as a substitute for luxury ivory and bone.

SEATED FIGURE (*NKISI*)

Kongo people, coastal Zaire, Lower Zaire River region, 19th century

Wood with black surface coating, resin, and porcelain, 8½ x 3½ x 3⅛ in. (21.6 x 8.9 x 7.9 cm)

Estate of Henry J. Crocker
59.12.11

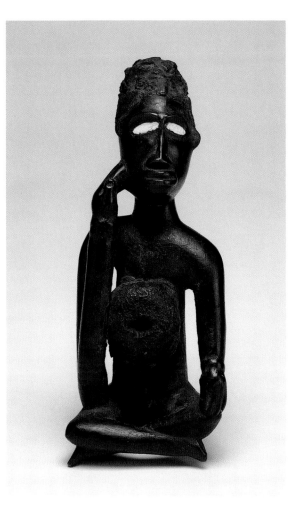

This seated power figure, *nkisi*, was once magically charged with the active ingredients that remain packed in its head and abdomen, and functioned as an intermediary to protect or heal.

In Kongo sculpture the nuances of gesture and pose are highly significant. This carved wood figure appears in a meditative pose, with hand to face, conveying confidence, elegance, and tranquility. Its striking silhouette reveals an exciting interplay between the solid form of the figure and the negative spaces that it creates.

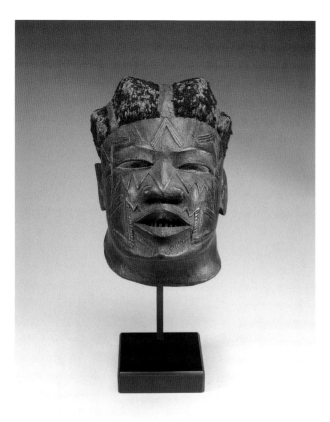

HELMET MASK
Makonde people, Mozambique,
early 20th century

Wood, hair, and paint
9¹³⁄₁₆ x 9¹⁄₁₆ x 13 in.
(24.9 x 23 x 33 cm)

Museum purchase, funds from Mrs.
Paul L. Wattis, Mr. and Mrs. J. Alec
Merriam, Diane and Charles Frankel,
Anonymous, Patricia and Edwin
Berkowitz, Helen Land, Mr. and Mrs.
James J. Ludwig, Mr. and Mrs. Harry
S. Parker III, Unrestricted Art
Endowment Fund, and AOA funds
raised at auction
1990.13

The Makonde people of southeast Tanzania and northern Mozambique made a variety of masks, both abstract and naturalistic. Realistic helmet masks like this one, which may represent a Makonde leader, are worn in dances during male and female initiation rites that include the arts of masquerade. The dancers are usually raised on stilts and wear costumes that cover their bodies.

The powerful realism of this mask is enhanced by the addition of human hair and the distinctive and elaborately carved scarification patterns. The more abstracted treatment of ears, eyes, and jaw provides contrast, contributing to the mask's power as a great sculptural form. Ear ornaments symbolizing leadership were probably suspended from the pierced ears at one time.

MAGDALENE ODUNDO (b. 1950)
Vessel
Nairobi, Kenya, 2000

Oxidized earthenware
24¾ x 9¾ x 9¾ in.
(62.9 x 24.8 x 24.8 cm)

Museum purchase, Anita Jaron Spivack
Memorial Fund
2002.71

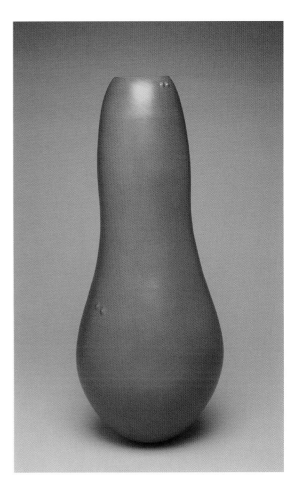

Magdalene Odundo is a true citizen of the world, and her ceramic work is a testament to her cosmopolitan background. She was born in Nairobi, Kenya, and schooled in Africa, India, and Britain. Her inspirations spring from the pottery of Africa, America, Asia, and Europe, and she freely incorporates the formal aspects of those ceramic traditions with idealized realistic forms. Untitled vessels like this one, with elongated and sleek lines, are the epitome of modern elegance. Yet its clearly distinguishable belly, waist, backbone, and hips define it as earthy and anthropomorphic.

Unlike other African pots, which were made to work as storage or fermentation containers, this vessel's function is to be beautiful and evocative. In this manner, Odundo's ceramics bridge the gap between traditional and contemporary African art, demonstrating a continuity of creativity.

Art of Oceania

CEREMONIAL MASK

Torres Strait, Mabuiag Island,
Australia, early 19th century

Turtle shell, cassowary feathers,
cowry shell, abalone shell, mussel
shell, fiber, human hair, white lime,
red paste, pigment, and tradecloth
24$\frac{7}{16}$ x 24$\frac{7}{16}$ x 19$\frac{11}{16}$ in.
(62.1 x 62.1 x 50 cm)

Gift of Marcia and John Friede
2001.62.11

This striking mask, composed of at least eleven different materials, is a miracle of preservation. Its underlying structure consists of numerous pieces of turtle shell, which were cut to create a latticework that was sewn or glued together. Once the designs were cut into the heated and bent shell they were inlaid with delicate pigments. Perhaps to provide further visual and auditory effect, bundles of shells and seedpods were hung on the underside of the mask and attached to twigs with twine and paste. Additional bundles of black cassowary bird feathers highlighted by V-shaped white feathers were attached to the edges of the mask, and red textile streamers were added. A composite work of art that is truly astonishing, it was worn in mortuary ceremonies that represented legendary or historic ancestors.

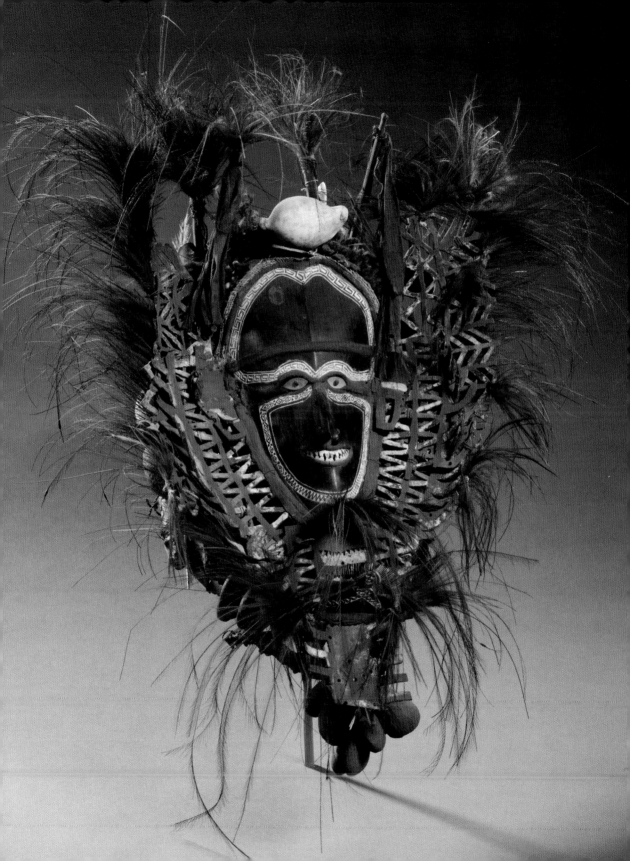

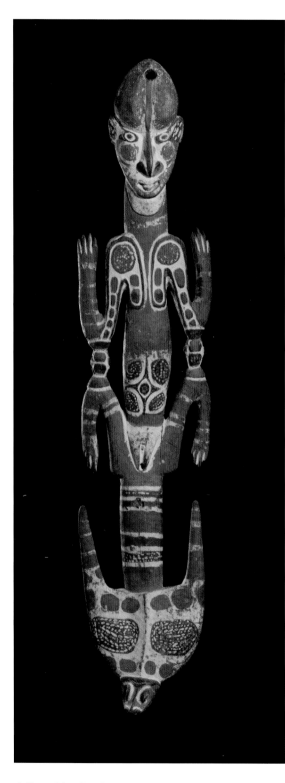
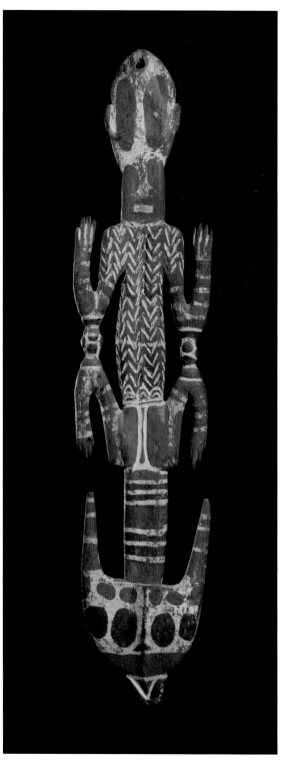

SUSPENSION HOOK

Iatmul people, East Sepik Province,
Papua New Guinea, 19th century

Wood and paint, 53⅛ x 11⁷⁄₁₆ x 1¹⁵⁄₁₆ in.
(134.9 x 29.1 x 4.9 cm)

Museum purchase, Mrs. Paul L. Wattis Fund
2000.172.2

A masterpiece of design, this boldly carved suspension hook is in the shape
of a female ancestor spirit. The hook is elaborately painted on both sides in
intense red, white, and black. Large and small dot and circle patterns and
rhythmic lines play against the solid and negative spaces of the sculptural
form. In many parts of New Guinea elaborately carved and painted suspen-
sion hooks in the form of human and animal ancestors were used for hanging
ceremonial objects inside cult houses. This hook suggests an ancestral spirit
giving birth to a crocodile child.

HUNTING SPIRIT (*YIPWON*)

Yimam people, Karawari River, East
Sepik Province, Papua New Guinea,
19th–20th century

Wood, 85$\frac{7}{16}$ x 5$\frac{1}{2}$ x 11$\frac{13}{16}$ in.
(217.1 x 14 x 30 cm)

Museum purchase, Mrs. Paul L. Wattis Fund
2000.172.1

This hook figure epitomizes the intensity and vigor that great New Guinea art
can embody. Created in the form of an abbreviated human being, this figure
has a bearded head, a body consisting of inward-curving pairs of opposed
hooks representing ribs, a single straight "heart" in the center, and a bent
single leg at the base. It is as much openwork as it is mass, and the bulging
curves of the head and face echo the body's hook forms while endowing the
head with a spiritual prominence that is important for its function as power
center of the body.

Such figures, called *yipwon*, were representations of mythical ancestors and
their essences. They were kept in the men's ceremonial houses and activated
by ritual offerings that were intended to draw the spirit into the carving.

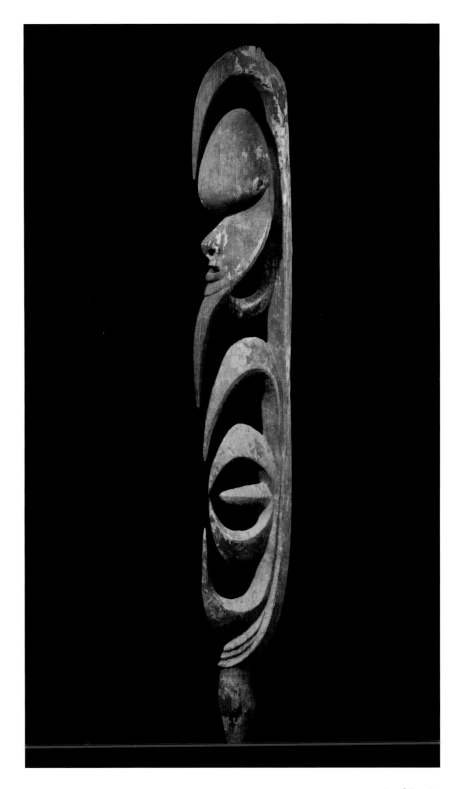

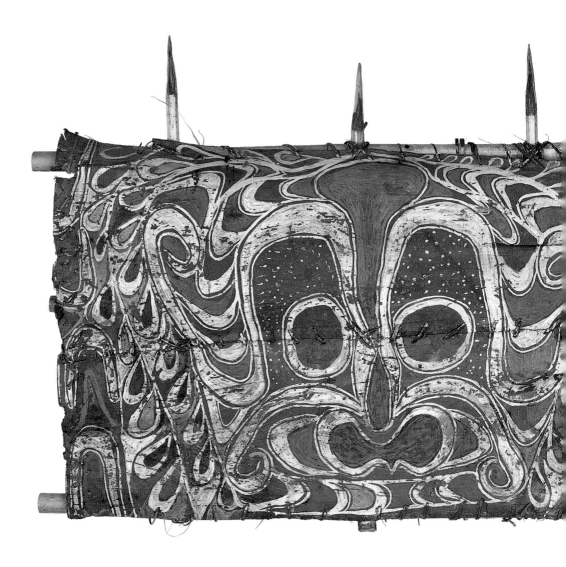

SKULL RACK

Sawos people, East Sepik Province, Middle Sepik,
Papua New Guinea, 20th century

Sago palm, bamboo, rattan, and earth pigments
77 x 36 in. (195.6 x 91.4 cm)

Museum purchase, Mrs. Paul L. Wattis Fund
2000.172.6

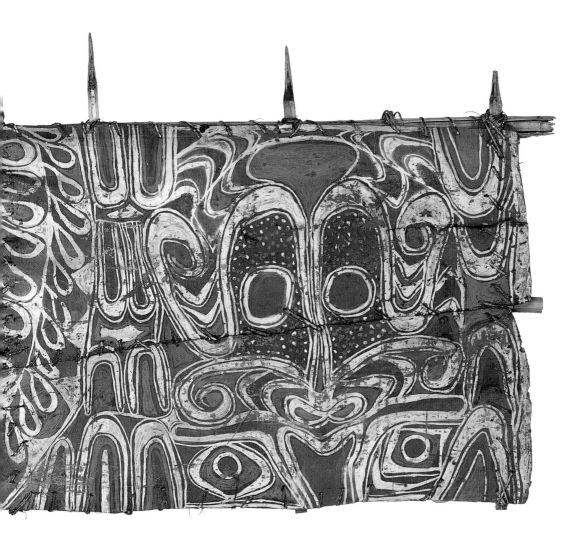

This amazingly well-preserved skull rack is made of the flattened spathes, or protective sheaths, that cover the fruit of the sago palm, which have been lashed onto a framework of bamboo and then painted with two swirling exuberant faces of ancestors. In historic times, the skulls of ancestors or slain enemies were over-modeled with clay and then attached to the bamboo points of skull racks. In this way connections were maintained with the ancestral spirits or powers of the other world. Thus the art of the Sawos people often serves to honor these beings, providing a system of communication among the human, natural, and spirit worlds.

SLIT GONG

Yuat people, Yuat River, Lower Sepik,
Papua New Guinea, 19th–20th century

Wood, 118⅛ x 33⁷⁄₁₆ x 25⁹⁄₁₆ in.
(300 x 85 x 65 cm)

Gift of Marcia and John Friede
2001.62.9

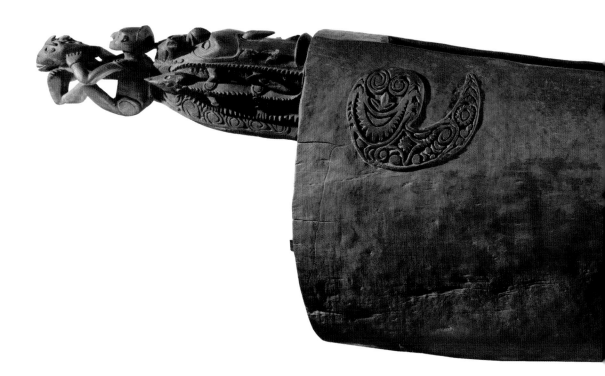

Slit gongs were used to impersonate spirit voices, send messages, and call meetings. They were often kept inside the men's ceremonial houses, sometimes arranged in pairs according to family residence patterns in the community. This slit drum is nearly nine feet long. Perhaps for ease in movement it has sizeable lugs at each end.

The hollowed-out trunk of a hardwood tree formed the resonant cavity, but for the sound to carry a long distance a narrow slit was required on the top. The sound of this type of gong could travel great distances over land and sea. Every adult had an individual signal or message name. In addition to pounding out ritual sounds, it was also possible to send out death notices, cyclone alerts, or accusations of stealing to the community.

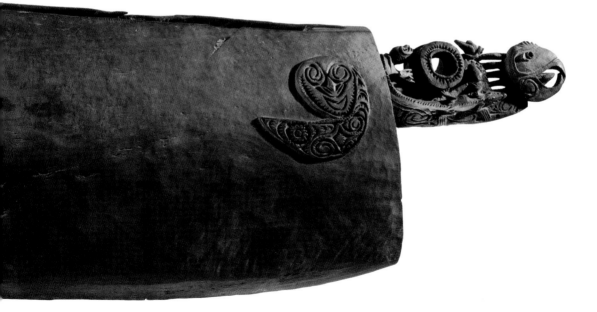

GABLE MASK FROM A CEREMONIAL HOUSE FACADE

Sawos people, Torembi Village, Middle Sepik, Papua New Guinea, 20th century

Sago palm, plaited works, and pigments, 63 in. (160 cm)

Museum purchase, Mrs. Paul L. Wattis Fund 2000.172.7

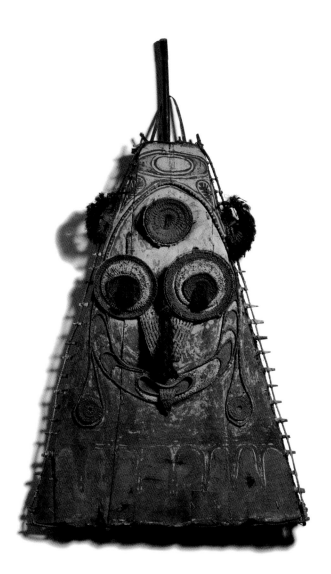

This impressive mask was once the central element in an elaborate gable facade of a ceremonial house. All who entered would pass under this formidable image. It represents the primordial ancestor who has become a guardian spirit. Thus there is an ongoing interaction between the men's ritual community and its mythic origins.

The mask is fashioned from four strips of sago palm spathe that have been stretched across a bamboo framework and lashed together with rattan. A plaited decoration forms the bulbous eyes, nose, and circular forehead decoration, and outlines the mouth and ear ornaments. These features and the outstretched tongue are emphasized in white, red, orange, and black paint.

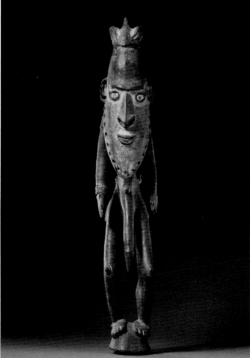
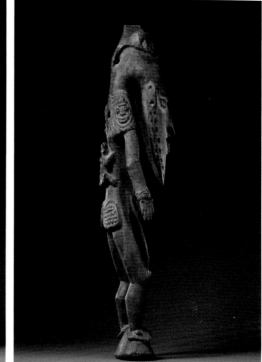

FIGURE FOR A SACRED FLUTE

Biwat people (formerly known as
Mundugamor), Yuat River, East
Sepik Province, Papua New Guinea,
19th–20th century

Wood, pearl shell, and pigment
21⅝ x 4⁵⁄₁₆ x 6⁵⁄₁₆ in. (54.9 x 11 x 16 cm)

Gift of Marcia and John Friede
2001.62.6

In much of the art of New Guinea the head is greatly enlarged, emphasized, or exaggerated. This sculpture consists of a standing male ancestor figure with an elongated head, attenuated arms held away from the body, and powerfully flexed legs. Incised faces of ancestors appear on the shoulder blades, and a small figure is carved on the back above the decorated buttocks. The beard is pierced numerous times beneath perforated ears. The flashing eyes are inset with pearl shell inlays, and the expression and intense coloration are dazzling.

Objects like this one were set into the upper part of long bamboo flutes, which were among the most important and sacred objects of the Biwat people.

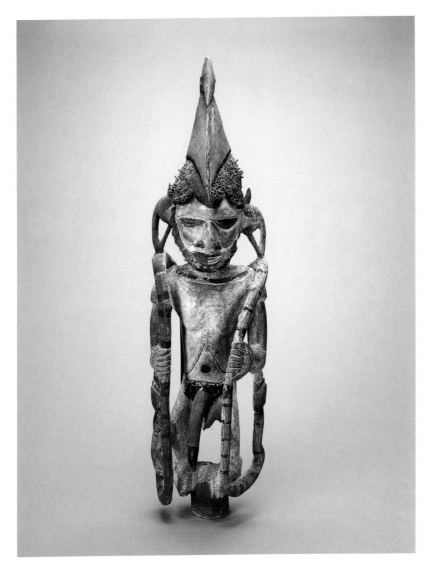

MALE ANCESTOR FIGURE
Northern New Ireland,
Melanesia, 19th century

Wood, pigment, fiber, and twigs, 30¾ x 8½ in.
(78.1 x 21.6 cm)

Museum purchase, gift of Mrs. Paul L. Wattis
and the Fine Arts Museums Acquisition Fund
1986.16.2

Memorial carvings such as this are used in complex ritual cycles called *malanggan*, which are the most important ceremonial rites in Northern New Ireland societies and can take years to complete. They celebrate ancestral propitiation and initiation as well as funerary rites to honor the dead. This important and rare figure is unique for its closed eyes, which give it an inward, brooding quality, and it may represent a dead man. He holds two snakes, which form loops over his shoulders. Each snake bites or holds its own tail. Despite some stylization and exaggeration of bodily proportions, the figure is naturalistic.

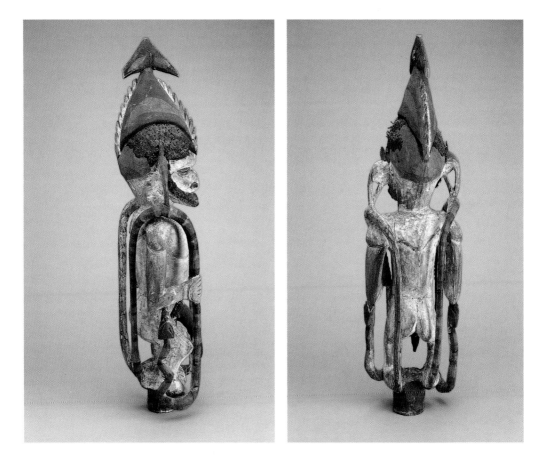

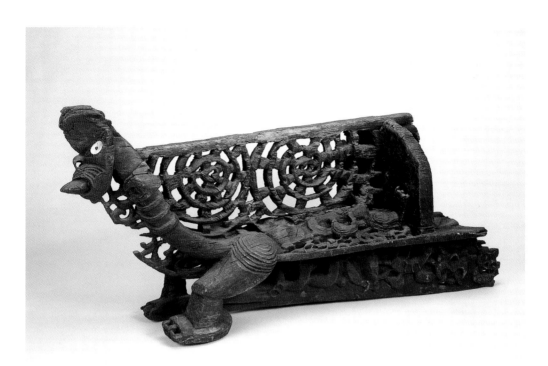

CANOE PROW

Ngati Porou people, Maori,
East Coast, New Zealand,
early 19th century

Wood and shell, 22¼ x 46 x 18 in.
(56.5 x 116.8 x 45.7 cm)

California Midwinter International
Exposition
5524

This extraordinary canoe prow would have been lashed to the front of a Maori war canoe. The crouching figure, with its fiercely protruding tongue and identifying tattoo markings, was meant to frighten the enemy in battle. Although the figurehead is weathered, the masterful skill used to create its intricate pulsating design is apparent. Great care was taken during the delicate carving process in order to keep the wood from splitting.

Highly prized canoe prows might take as long as two generations to complete. After a canoe was no longer useful, the prow would be removed and attached to a new vessel. This figurehead, dating from the early nineteenth century, was probably carved with stone tools.

CONTAINER IN HUMAN FORM
Batak people, Sumatra, Indonesia,
20th century

Bamboo, metal, and dark pigment
9¾ x 5 x 4¾ in. (24.8 x 12.7 x 12.1 cm)

Gift of George and Marie Hecksher
L04.1.1a–b

This compact bamboo and metal container is a masterpiece of carving from the Batak culture of Northern Sumatra. Its anthropomorphic lid, central vessel, and base are carved in a powerful, twisting pose topped by a head with an intense facial expression. It likely functioned as a receptacle for the magical substances carried by a priest or shaman, and its form emphasizes the protective function and nature of such a container.

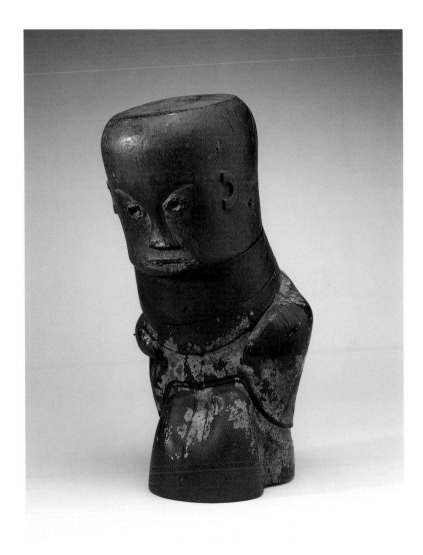

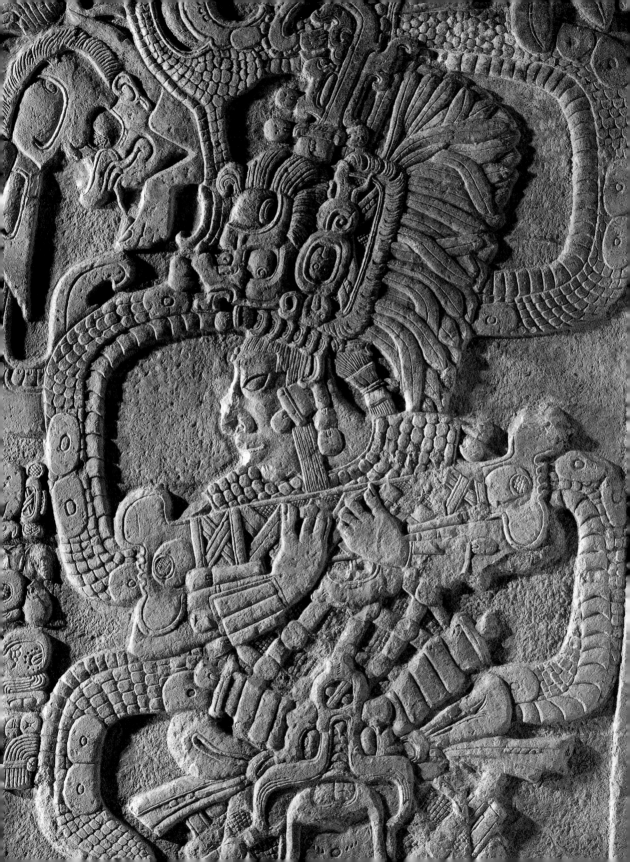

Art of the Americas

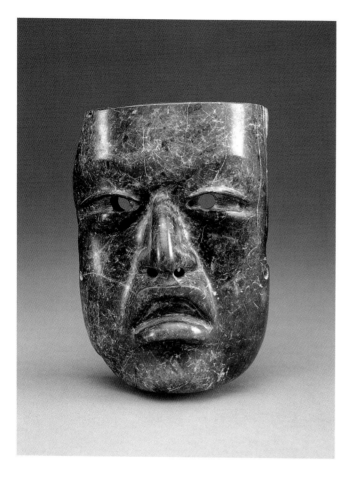

An Olmec deity or aristocrat may be portrayed by this
exquisite work, finely carved from a sacred green stone. For
the Olmec the quick, agile, and powerful jaguar was a
symbol of authority and prowess in hunting and battle, as
well as an integral part of their mythology and a spirit com-
panion for shamans. This face displays features associated
with the were-jaguar, a mythical half-human, half-feline
being, characterized by a downturned mouth with a flared
upper lip, puffy cheeks, and almond-shaped eyes. On the
left side of the mask and extending down the cheek is an
incised carving of a human profile, also with were-jaguar
traits. The holes in the eyes, nostrils, and sides indicate that
the mask may have been worn.

TRIPOD BOWL

Coastal Veracruz, Mexico,
AD 300–700

Earthenware and paint
13⅛ in. (33.3 cm)

Museum purchase, Dean
Barnlund Bequest Fund
1994.73

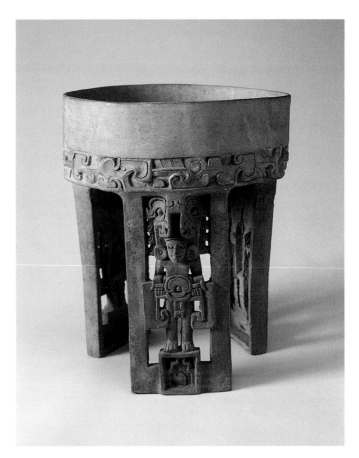

The three openwork legs of this extraordinary bowl all bear the same standing ritual figure, who wears a large headdress that may represent a classic period war serpent (part snake and part jaguar). In his hands, the figure appears to hold an object of some weight and substance, which may be a ceremonial bar of office, but resembles the "jaws of the sky," a Zapotec symbol of divinity. The figure stands on a square base with a stepped image inside. This configuration is a common Mesoamerican sign for an altar, temple platform, or sacred mountain. The unusual imagery reflects strong Maya, El Tajin, Oaxacan, and Teotihuacan influences.

The bowl comes from coastal Veracruz, near El Tajin, which was a major religious and trade center with more ceremonial ball courts than any other Mesoamerican site.

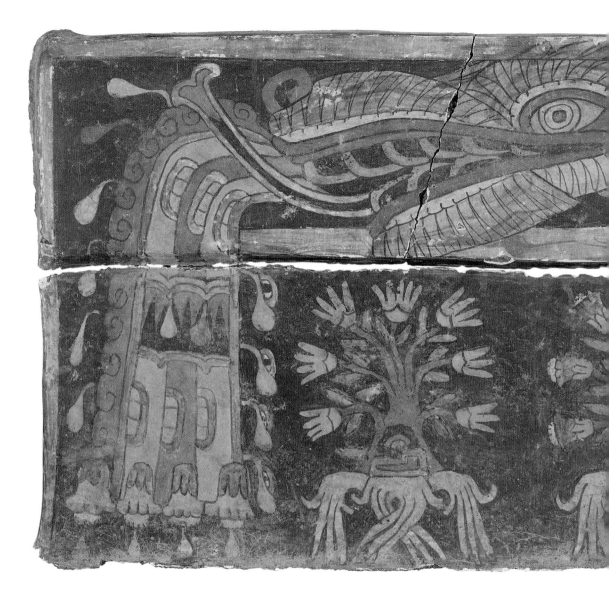

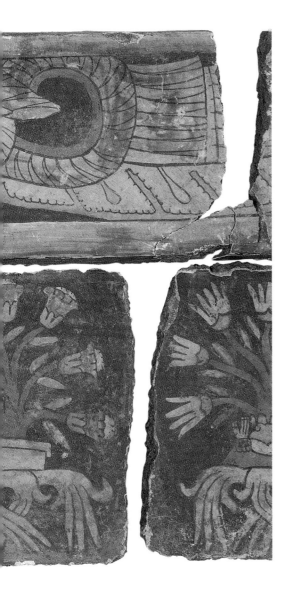

FEATHERED SERPENT AND FLOWERING TREES [detail]

Teotihuacan people, Techinantitla, Teotihuacan, Mexico,
AD 600–750

Volcanic ash and mud backing, lime coating, and mineral pigments
23¼ x 159½ x 2¼ in.
(59.1 x 405.5 x 5.7 cm)

Bequest of Harald J. Wagner
1985.104.1a–b

One of the most beautiful rooms in the city of Teotihuacan must have been the one featuring murals of feathered serpents and flowering plants with glyphs. According to a reconstruction, there were four serpents with trees under them decorating the four walls of this room. This fifteen-piece mural, from one of the most important complex urban centers in the New World, is the largest reconstruction of mural fragments in the museum's extensive collection.

The feathered serpent, a common motif in pre-Columbian art, is frequently associated with water or fertility and appears here with water flowing from its mouth down to the trees below. The thirteen flowering trees each contain different glyphs, or picture symbols, within their bases. These glyphs may name specific places, lineages, or ritual plants. Although no one can as yet decipher the glyphs or determine the language spoken, they suggest that the culture of Teotihuacan had a complex system of picture writing.

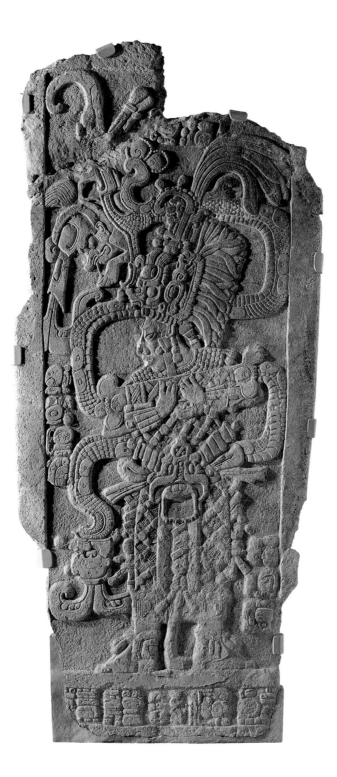

STELA WITH QUEEN IX MUTAL AHAW

Maya people, Southern Lowlands, Mexico or Guatemala, AD 761

Limestone, 92 x 42 x 3 in. (233.7 x 106.7 x 7.6 cm)

Museum purchase, gift of Mrs. Paul L. Wattis
1999.42a–k

This monumental stone carving comes from the southern Maya lowlands and was once part of a larger architectural setting that was built in tribute to Maya political leaders and gods. Stelae such as this one were erected to commemorate major political or historical events and establish royal lineages.

Kings and queens were active participants in the supernatural rites that lay at the conceptual heart of royal Maya power. In its intricate and unusual iconography, this rare monument depicts a queen with an elaborate headdress and a beaded net overskirt associated with maize deities. The event portrayed is a ruler's vision quest, the central act of the Maya world. In it rulers performed rituals of bloodletting as reciprocal offerings to the gods, who had shed their own blood to create humanity. A large serpent wraps itself around the queen's body, making four turns. From its gaping mouth emerges K'awiil, a principal Maya deity that the ruler has conjured as a vision, presumably after performing a bloodletting ritual.

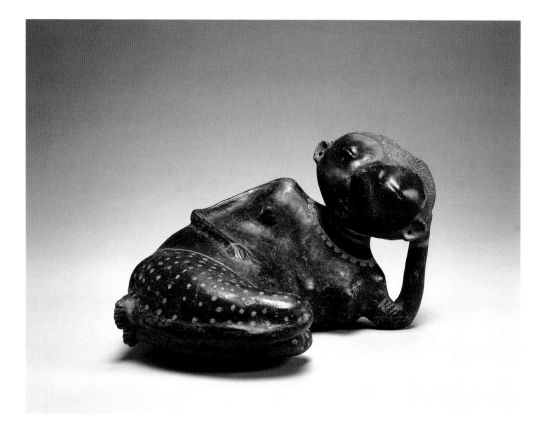

RECLINING FEMALE FIGURE
Nayarit people, Chinesco style,
West Mexico, 2nd century
BC–3rd century AD

Earthenware, orange and beige
slip, and resist decoration
7 x 12½ in. (17.8 x 31.8 cm)

Promised gift of the Land Collection
T#92.166.13

The cultures of West Mexico buried their dead in
shaft tombs accompanied by a variety of ceramic
offerings. Fertility imagery often appears in these
offerings and is undoubtedly related to concepts
of death and the afterlife. This serene female
figure reclines in an elegant yet relaxed position
reminiscent of an odalisque. She exhibits the typi-
cal heart-shaped face and slit eyes characteristic
of the Chinesco figures from Nayarit. Her hollow
body is highly burnished and decorated with a
negative-resist method, leaving a crisscrossed band
in red over her chest, probably representing body
paint or tattoos. Her dotted skirt and beaded
necklace are painted in beige slip. This piece clearly
demonstrates the hand of a masterful and
accomplished artist.

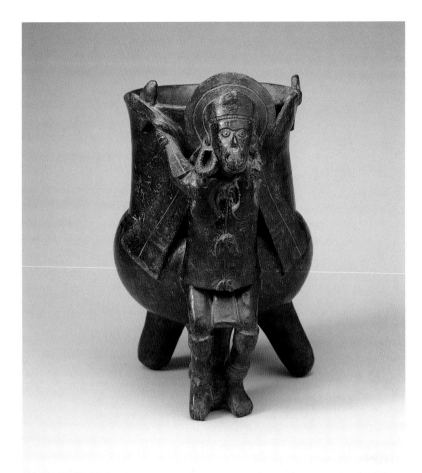

WARRIOR VESSEL

Mixtec and Aztec influences,
Guerrero or Oaxaca, Mexico,
AD 1000–1500

Earthenware, red slip, and black
pigment, 10½ x 8¼ x 6½ in.
(26.7 x 21 x 16.5 cm)

Museum purchase,
Mrs. Paul L. Wattis Fund
1979.6

Most probably an offering for an important tomb,
this detailed vessel decorated with a finely modeled
standing figure shows a blend of Mixtec and Aztec
styles. The figure wears battle armor, probably
made of cotton, and carries a hafted axe or sacrifi-
cial knife in his right hand. He may represent
Tlaloc, the ancient rain god, identified by the fangs
that protrude from his mouth. The Mixtecs were
the last of the great cultures centered around
Oaxaca from around 1200 until about 1525. This
vessel may have come from that region or the coast
of Guerrero.

FEATHER TUNIC
Nasca people, South Coast Peru
AD 300–600

Cotton and feathers
48 x 67 in. (121.9 x 170.2 cm)

Museum purchase, gift of the Museum
Society Auxiliary
1996.48

This extraordinary feathered tunic is of a type worn by Nasca royalty. Woven on a framework of plain-weave cotton, the garment is worked in brilliant feathers of yellow, blue, red-orange, black, and green. The prominent, luminous yellow feathers almost certainly symbolize the sun, which was worshipped by many ancient peoples of the Andes. In ancient Peruvian cultures, feathers (which were traded over great distances) were considered luxury items, and their use was reserved for the elite. The feathers of tropical birds like the macaw or parrot were especially prized, valued for their bright colors, their fragility, and their symbolic qualities. While elaborate feather garments would be worn during an individual's lifetime, they were also interred with the owner, along with a number of other personal items of burial wealth.

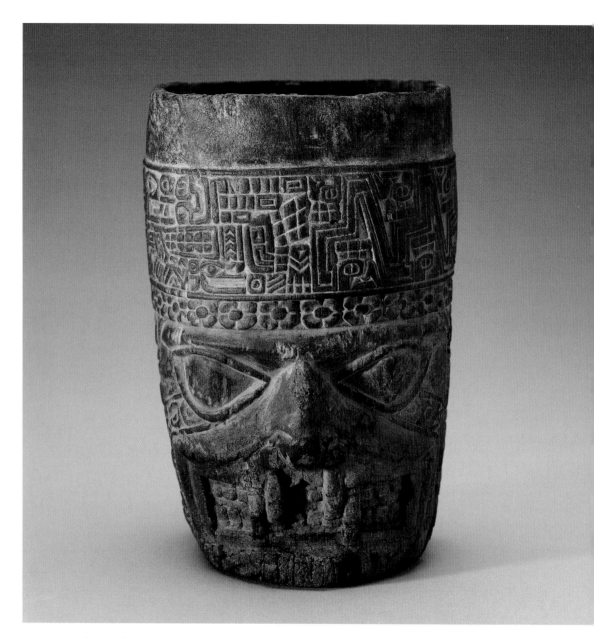

BEAKER (*KERO*)
Huari people, Peru, AD 656–822

Wood, 6¾ x 5½ x 4⅜ in. (17.2 x 14 x 11.1 cm)

Museum purchase, David I. Clayton Acquisition
Fund and anonymous gift
2003.3

This rare Peruvian vessel, known as a *kero*, has the characteristic straight sides of a Huari ritual vessel, but is carved in the form of a composite head, combining a human face with a jaguar or feline mouth bearing two pairs of large incisors. This striking combination of human and animal attributes may indicate a religious or shamanic transformation, perhaps representing a fanged divinity or deity. The eyes are large and wide, with stylized "tear pattern" bands flowing from each down the sides of the face. The head is topped by an elaborate and boldly carved band of decoration. The band includes stepped bird or raptor heads in profile and a griffin-headed figure looking back over its body toward a front-facing head.

Huari, a sprawling pre-Inca city that flourished from AD 650 to 1000, had widespread influence over the central Andes people, as well as those on the South and Central Coasts.

MOSAIC FIGURE

Huari people, Peru, AD 700–900

Wood core, bitumen, spondylus shell, mother-of-pearl, saltwater
clam, jadeite or malachite, bone, and hammered silver
4⁹⁄₁₆ x 3 in. (11.6 x 7.6 cm)

Museum purchase, Unrestricted Art Endowment Fund, Mrs. Paul
L. Wattis, Mr. and Mrs. J. Alec Merriam, Mr. and Mrs. Harry S.
Parker III, Mr. and Mrs. Joseph L. Seligman Jr., Mr. and Mrs.
James J. Ludwig, Mr. and Mrs. Leonard Kingsley, Professor James
H. Morrow and Emily Rose Morrow, David Mayer, and the Ellen
and Klaus Werner Fund in Honor of Ian White
1989.4

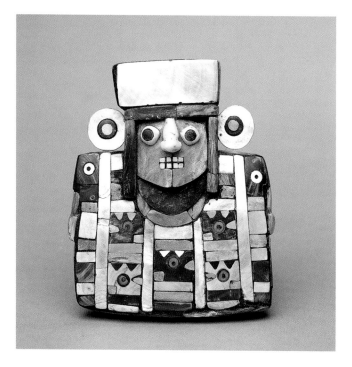

This delightful standing figure of a Huari dignitary (now missing its legs) is shown wearing
an interlocking tapestry tunic with designs of feline heads in profile, rectangular bars, and
concentric circles. Modeled on a wooden core, it has mosaic inlay affixed with bitumen
on both sides. The figure was probably a burial offering for a high-ranking individual of
the Huari empire, which dominated the North, Central, and South Coasts of Peru
between AD 600 and 1000. Lavish burial offerings provide a glimpse of the wealth and
pomp that existed in Huari times.

GIFT BASKET

Pomo tribe, Mendocino County, California,
late 19th century

Three-rod foundation, probably of willow roots, with weft
materials of sedge root, acorn woodpecker and quail
topknot, mallard and meadowlark feathers, and Washington
clamshells, 2 x 4¼ in. (5.1 x 10.8 cm)

Gift of Mrs. Samuel G. Fleishman
49.13.4

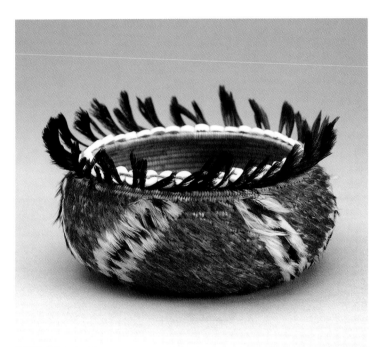

Sometimes referred to as "jewel baskets" because of their rich colors, minia-
ture feather baskets illustrate the high level of achievement among Pomo
basket weavers of California. The incorporation of feathers in the weaving
process required great expertise and time, since their use called for the same
careful preparation that is given to the fibers used in basket weaving. This
basket was most certainly designed to show the skill and taste of its maker,
and perhaps was presented to a friend as a gift.

Painting, Sculpture, and Decorative Arts

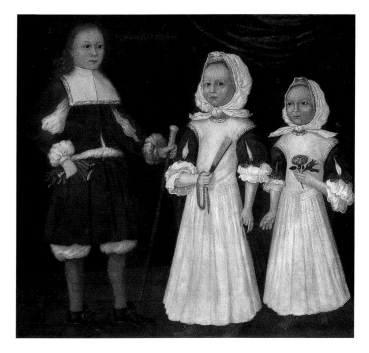

ATTRIBUTED TO THE FREAKE-GIBBS LIMNER

(ACTIVE BOSTON, MASSACHUSETTS, CA. 1670)

David, Joanna, and Abigail Mason, 1670

Oil on canvas, 39 x 42½ in. (99 x 108 cm)

Gift of Mr. and Mrs. John D. Rockefeller 3rd
1979.7.3

David, Joanna, and Abigail Mason is the earliest American painting in the museum's collection and the only known American painting from the seventeenth century to show more than two figures. It is a complex and captivating portrait of three of the five children of Arthur and Joanna Mason, prominent Boston residents. The artist, known only by his recognizable style seen in portraits of important colonial families, was a talented painter in the English provincial manner, continuing the linear, geometric traditions of Elizabethan and Jacobean painting. Using small brushstrokes and slight color gradations, the artist characterized the children as fashionable and prominent adults, giving them attributes of wealth and status. Lace, coral beads, kid gloves, and a silver-handled walking stick, all handsomely detailed, testify to the success of Boston's mercantile class and belie the romantic notion of an exclusively somber Puritan life.

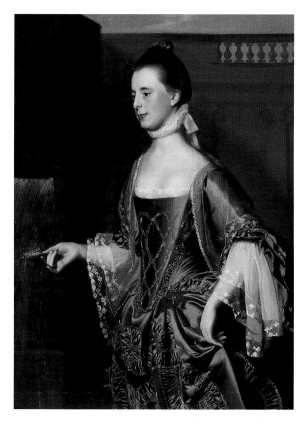

JOHN SINGLETON COPLEY (1738–1815)
Mrs. Daniel Sargent (Mary Turner), 1763

Oil on canvas, 49½ x 39¼ in. (126 x 100 cm)

Gift of Mr. and Mrs. John D. Rockefeller 3rd
1979.7.31

Copley is widely regarded as one of America's foremost native painters of genius, an artist whose technical virtuosity can match the best of eighteenth-century European portraitists. In his early maturity, he painted Mary Turner, granddaughter of the Salem merchant who built the *House of the Seven Gables,* perhaps to commemorate the sitter's marriage in 1763 to Daniel Sargent, a wealthy Gloucester ship owner. The work is an elegant example of the largely self-taught artist's ability to reproduce the elaborate effects of light playing on differing surfaces, from Mrs. Sargent's delicate features to the opulent textures of her gown. The sitter later bore witness to Copley's painstaking technique, telling her son, the artist Henry Sargent, that she had "sat to him fifteen or sixteen times! Six hours at a time!!"

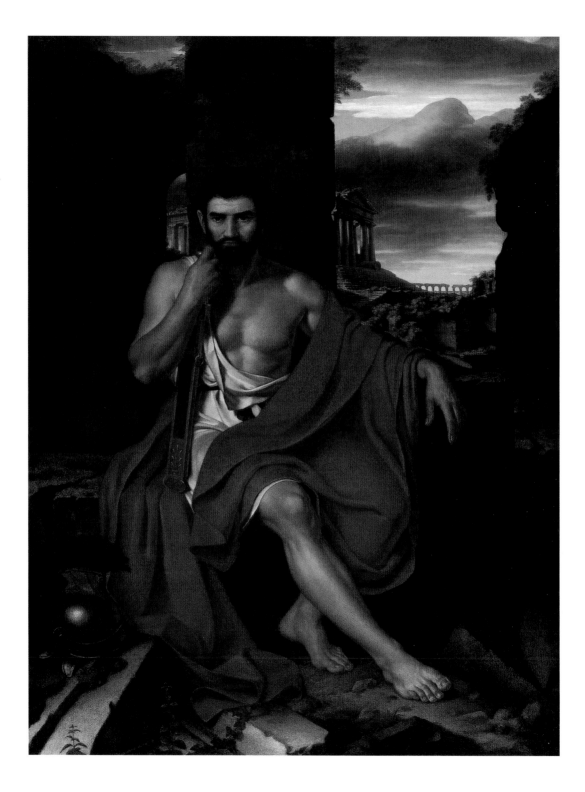

JOHN VANDERLYN (1775–1852)

Caius Marius Amid the Ruins of Carthage, 1807

Oil on canvas, 87 x 68½ in. (221 x 174 cm)

Gift of M. H. de Young
49835

The winner of a gold medal at the 1808 Paris Salon, Vanderlyn's *Marius,* by virtue of its scale, treatment, and subject (which is taken from Plutarch's account of Caius Marius, the Roman consul), signals the ambition of the artist. Using the symbolic vocabulary of French history painting, Vanderlyn depicts Marius seated as a former military hero, brooding, alone, and defeated in his ambitions. Hoping to foster the development of history painting in America, Aaron Burr had sent Vanderlyn to study in Paris and Rome. *Marius,* painted in Rome, was an immediate success. The artist refused the opportunity to sell the work in France and instead exhibited it and other monumental paintings extensively from New York to Havana. Unfortunately, Vanderlyn failed to spark the patronage that he had hoped to inspire. In 1834 he finally sold *Marius* to Leonard Kip, his neighbor in Kingston, New York. The painting traveled to California in the 1850s with the household effects of Kip's son, Canon William Ingraham Kip, later first Episcopal bishop of the state.

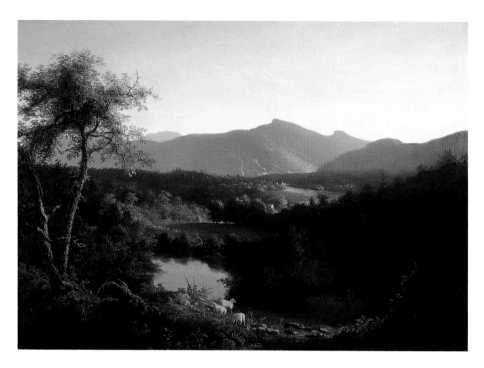

THOMAS COLE (1801–1848)
View near the Village of Catskill, 1827

Oil on wood panel, 24½ x 35 in. (62.2 x 88.9 cm)

Gift of Mr. and Mrs. John D. Rockefeller 3rd
1993.35.7

There is no one whose name is more prominently connected with the Catskill Mountains and the Hudson River Valley of New York than the English-born artist Thomas Cole. As American cities became more congested in the nineteenth century, the countryside with its picturesque scenery captured the American imagination, and Cole's careful observation and love of nature contributed to the early success of landscape painting as a national art. Westward expansion and the opening of the Erie Canal in 1825 revealed the vast scale and natural wonders of the continent. This new awareness of the grandeur of the American wilderness inspired a group of artists led by Cole, known as the Hudson River School, to paint dramatic, natural scenes that were romantic yet meticulous in detail. At the same time, authors such as Nathaniel Hawthorne, James Fenimore Cooper, Henry David Thoreau, and Ralph Waldo Emerson were expressing this nationalistic pride in a new romantic literature. Cole painted this view looking west from the town of Catskill toward the Catskill Mountains at least ten times, beginning in 1827 with *View near the Village of Catskill*.

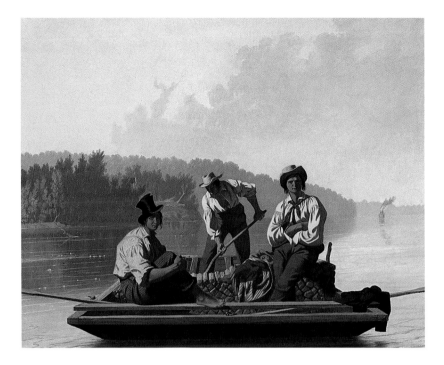

GEORGE CALEB BINGHAM (1811–1879)
Boatmen on the Missouri, 1846

Oil on canvas, 25⅛ x 30¼ in. (63.5 x 76.2 cm)

Gift of Mr. and Mrs. John D. Rockefeller 3rd
1979.7.15

Bingham's decision to paint life on the river was an apt one, as the vital arteries of commerce and communication provided a backdrop to his own experiences. Among the first of the artist's celebrations of Missouri river life, *Boatmen on the Missouri* shows two men resting from their task of selling wood to passing steamboats, while a third man attends to a chore in the rear of the shallow boat. The figures, statuesque with massive limbs and direct gazes, are grouped as a solid pyramid pinned into place by the oars that touch the left and right edges of the picture. Although Bingham painted the boatmen with rich, strong colors, he used the most delicate gradations of pastel shades to evoke the quiet landscape wrapped in early morning mist. *Boatmen on the Missouri*, one of the earliest views of daily life on the Western frontier to find a popular audience on the East Coast, was a prize in New York's American Art-Union lottery of 1846. Sent to the winner in New Orleans, the painting was lost to public view for 120 years until its widely heralded discovery in a California private collection in 1966.

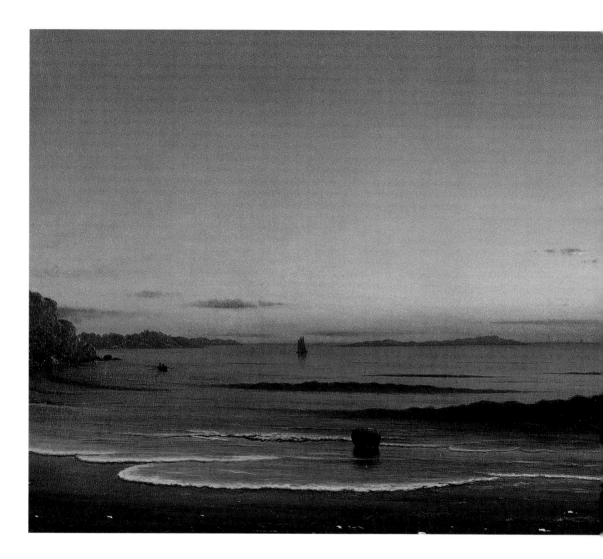

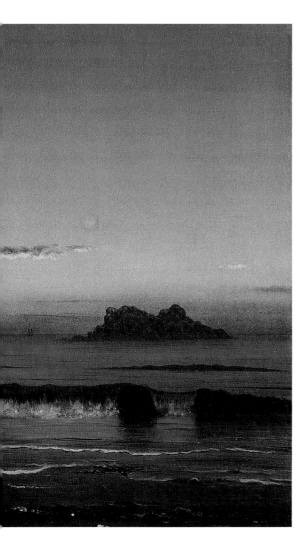

MARTIN JOHNSON HEADE (1819–1904)
Singing Beach, Manchester, 1863

Oil on canvas, 20 x 36 in. (50.8 x 91.4 cm)

Gift of Mr. and Mrs. John D. Rockefeller 3rd
1993.35.12

The breadth and volume of work produced by Heade is perhaps unrivaled by any artist of nineteenth-century America. Although his earliest paintings are primarily portraits, along with a few genre and allegorical works, the versatile and prolific artist shifted his attention later in his career to the subjects for which he is known today—still lifes and landscapes. He is often best remembered for his elegant paintings of the New England and mid-Atlantic coast and his exploration of light and atmosphere. Only about thirty seascapes of Heade's survive, and they are among the most dramatic of American paintings. Among the many seascapes he painted in 1863, his most productive year, *Singing Beach, Manchester* focuses clearly on a single wave, which breaks up from the calm water. A cool, rosy horizon separates the gray sky from the gray sea at this popular and picturesque seaside resort just north of Boston.

FREDERIC EDWIN CHURCH
(1826–1900)
Rainy Season in the Tropics, 1866

Oil on canvas, 56¼ x 84¼ in.
(142.9 x 213.7 cm)

Mildred Anna Williams Collection
1970.9

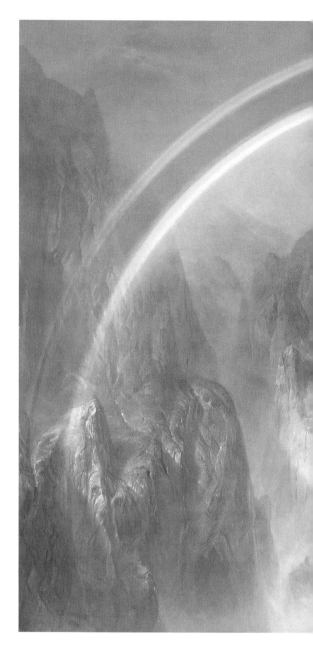

Frederic E. Church's vast landscape panoramas were among the most celebrated paintings of the nineteenth century. The large, romantic compositions of tropical or arctic scenery (often based on his broadly worked, luminous sketches) were frequently exhibited in specially lit spaces where their minute detail and convincing atmosphere could mentally transport the viewer to a distant land. During the nineteenth century Americans viewed nature as the most profound manifestation of the divine, and artists frequently made landscapes the vehicle for expressing nationalistic or moralistic sentiments. *Rainy Season in the Tropics*, one of the last of Church's grand tropical vistas, is a complex blend of naturalism and fantasy. In spite of the wholly convincing unity of the atmosphere, the panoramic landscape merges a distant view of the rugged Ecuadorian Andes with a lush, rocky outcropping characteristic of the Jamaican highlands. The dazzling double rainbow, a symbol of divine blessing, binds the two and adds a celebratory element to the picture.

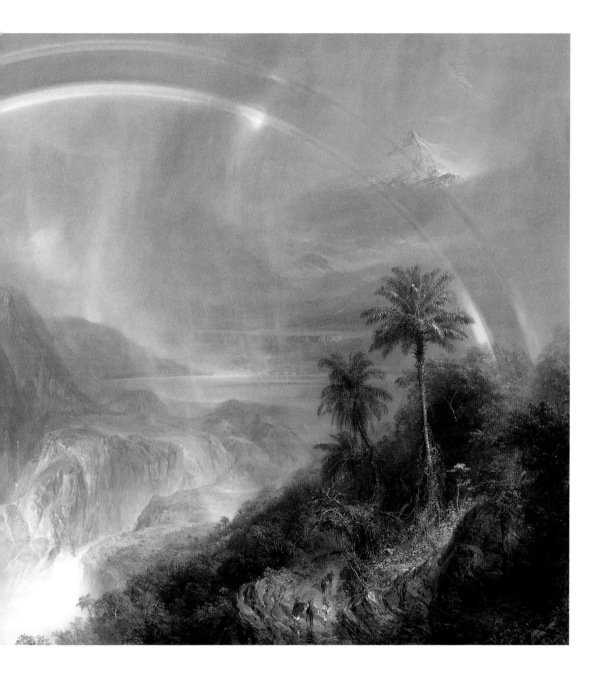

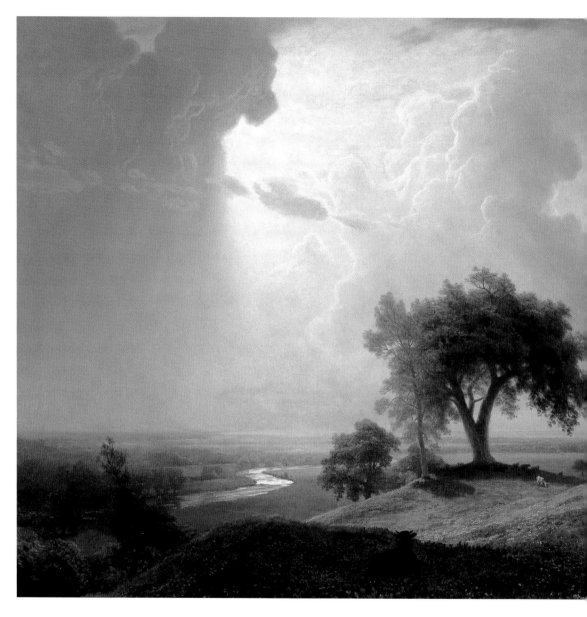

ALBERT BIERSTADT (1830–1902)
California Spring, 1875

Oil on canvas, 54¼ x 84¼ in. (138 x 214 cm)

Presented to the City and County of San Francisco
by Gordon Blanding
1941.6

Bierstadt made three journeys to the West, spending several years during the 1860s and 1870s in and around the San Francisco Bay area. It was during this time that he attained his greatest success as the preeminent artist of the American West, with his large-scale and finely detailed records of the grandeur and beauty of that newly explored region commanding high prices from collectors in the East. *California Spring*, completed in 1875 when the artist was in New York City, received prominent exposure when it was shown in several important exhibitions. The broad panoramic view of the flat Sacramento Valley, as it might be seen from the low-lying foothills of the Sierra Nevada, is depicted with the atmospheric splendor of billowing clouds and dramatic light. The peaceful, reassuring pastoral scene of grazing cattle and fertile land reflects the gentler grandeur of this often wild Western landscape. Away in the right distance stands the dome of the State Capitol in Sacramento, completed only in 1869.

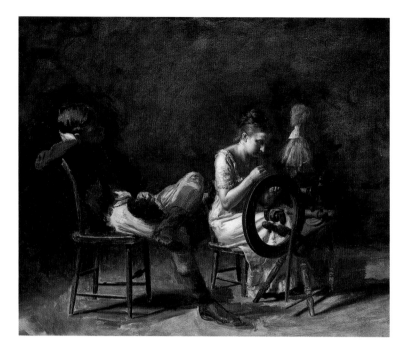

THOMAS EAKINS (1844–1916)
The Courtship, ca. 1878

Oil on canvas, 20 x 24 in. (50.8 x 61 cm)

Museum purchase, gift of Mrs. Herbert Fleishhacker,
M. H. de Young, John McLaughlin, J. S. Morgan and
Sons, and Miss Keith Wakeman, by exchange
72.7

Thomas Eakins, painter, photographer, and teacher, is best known for the carefully observed portraits and outdoor genre scenes in which he sought to record the physical appearance of the natural world. However, following the 1876 Centennial International Exhibition in Philadelphia with its colonial revival themes, he painted a series of more imaginative, historical scenes evocative of the eighteenth or early nineteenth century. *The Courtship* is one of these works; the clothing and spinning wheel reflect the colonial era, and the painting's golden light and air of psychological absorption elicit a poetic nostalgia for the simplicity of the nation's preindustrial past. Nonetheless, Eakins's sensitivity to pose, glance, and gesture suggests the forceful characterization and close study for which he is so well known. The artist has lavished great care on the realistic modeling of the figures in this intimate scene of a young man who has come to call on a girl and must wait while she continues to concentrate on her work.

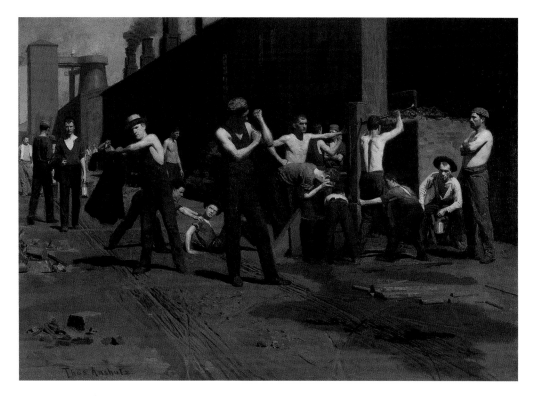

THOMAS POLLOCK ANSHUTZ (1851–1912)
The Ironworkers' Noontime, 1880

Oil on canvas, 17 x 23⅞ in. (43.5 x 60.6 cm)

Gift of Mr. and Mrs. John D. Rockefeller 3rd
1979.7.4

Despite the increasing urbanization of American life after the Civil War, few painters of the later nineteenth century were willing to take the unromantic facts of industrialization as subjects for their art. One exception was Thomas Anshutz, a student of Thomas Eakins and later his successor as instructor at the Pennsylvania Academy of the Fine Arts. In his painting of iron-foundry workers taking a noonday break, the figures form a friezelike band across the center of the canvas, their various postures and actions revealing Anshutz's intimate knowledge of anatomy and his mastery of classical composition. The foundry depicted here is more typical of one from Anshutz's childhood in Wheeling, West Virginia, during the middle of the nineteenth century. In this supreme example of the artist's work, one of the first fully realized paintings of an industrial subject in American art, he portrays the calm, dignified, even heroic workers in their most mundane activities, conveying a monumentality that belies the painting's small size.

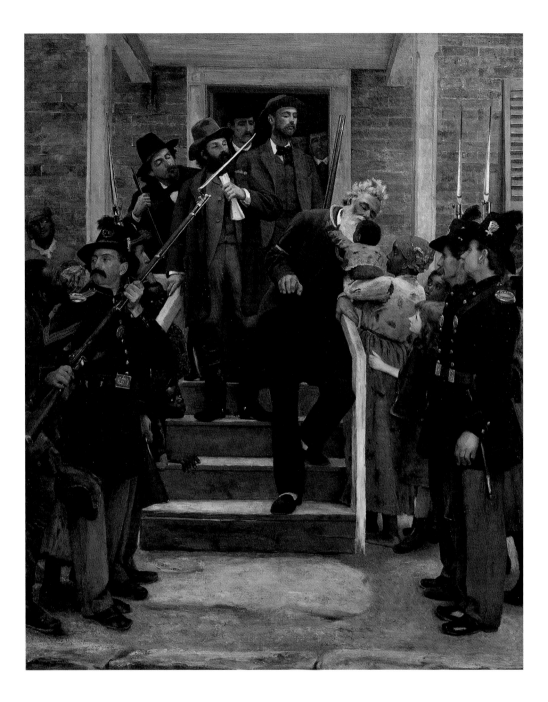

THOMAS HOVENDEN (1840–1895)

The Last Moments of John Brown, ca. 1884

Oil on canvas, 46⅛ x 38⅛ in. (117 x 97 cm)

Gift of Mr. and Mrs. John D. Rockefeller 3rd
1979.7.60

Like many of his contemporaries, Hovenden executed genre scenes of home and family life. Unlike most of these other painters, however, he wanted to advance social causes, particularly regarding the lives of people of African descent in America. Associated by marriage to a family of ardent abolitionist sympathizers and painting in a studio previously used as a center for the Underground Railroad, he focused much of his work on the recently freed people. Hovenden's most famous painting on this theme is *The Last Moments of John Brown*, which was referred to in the *New York Times* in 1884 as "the most significant and striking historical work of art ever executed in the republic." Brown's 1859 raid on the federal arsenal at Harpers Ferry and subsequent execution galvanized the nation. In the painting Brown is shown as he is being led away to the gallows with a noose around his neck. While abolitionists celebrated him as a martyr to the antislavery cause, Southern whites denounced him and his Northern supporters and formed militias to guard against slave uprisings.

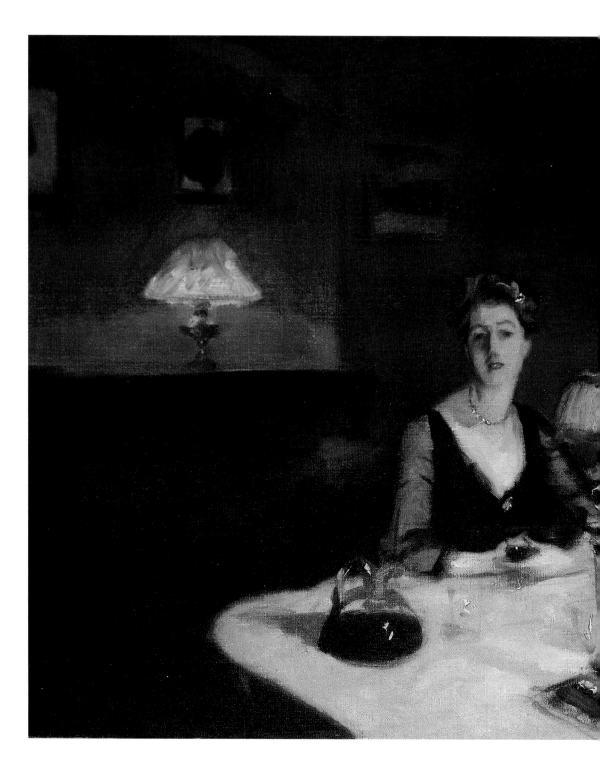

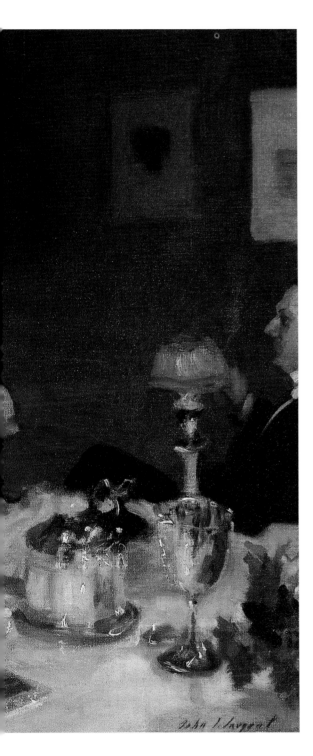

JOHN SINGER SARGENT (1856–1925)
Le verre de porto
(A Dinner Table at Night), 1884

Oil on canvas
20¼ x 26¼ in. (51.4 x 66.7 cm)

Gift of the Atholl McBean Foundation
73.12

Born to American parents living in Florence, Sargent went to schools in Italy and Germany, studied painting in France, and, although he always retained his American citizenship, lived from the mid-1880s principally in England. Among his earliest English patrons were Mr. and Mrs. Albert Vickers, portrayed in *Le verre de porto* in their well-appointed dining room at Lavington Rectory, near Petworth. Sargent used glazes of rich color and artfully placed touches of thickly applied paint, the latter particularly effective in creating the illusion of silver and glassware. His spontaneity, bold treatment, and unusual composition, placing Mrs. Vickers in the center of the painting while her husband's profile is barely included in the scene, provide an intimate and informal portrait of elegance and distinction, at the same time keeping with the modern impressionist sensibility. The isolation of the figures offers the psychological overtone that there is no possibility of communication between them.

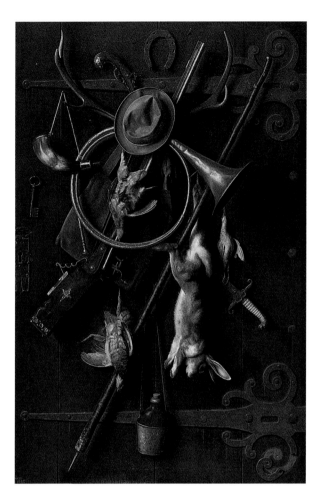

WILLIAM MICHAEL HARNETT
(1848–1892)
After the Hunt, 1885

Oil on canvas
71½ x 48½ in. (181.6 x 123 cm)

Mildred Anna Williams Collection
1940.93

Harnett, the best-known American nineteenth-century practitioner of *trompe l'oeil* (or "fool-the-eye" realism), painted four versions of *After the Hunt*. This version, done in Paris, was the last and largest painting of the series. Basing these works in part on nineteenth-century German photographs, he portrayed the weapons and devices of the hunt hanging alongside the day's trophies on a cracked and peeling door. Meticulously concealing all evidence of his brushwork, the artist has created within this shallow space a masculine world of richly textured objects that challenge the viewers' discrimination of illusion and reality. After the successful exhibition of this painting at the 1885 Paris Salon, it hung for more than thirty years in a popular New York saloon where it measured the sobriety of its customers, some of whom mistook the lifelike image for actual objects hanging on the wall.

MARY CASSATT

(1844–1926)

*Mrs. Robert S. Cassatt,
the Artist's Mother*, ca. 1889

Oil on canvas
38 x 27 in. (96.5 x 68.6 cm)

Museum purchase,
William H. Noble Bequest Fund
1979.35

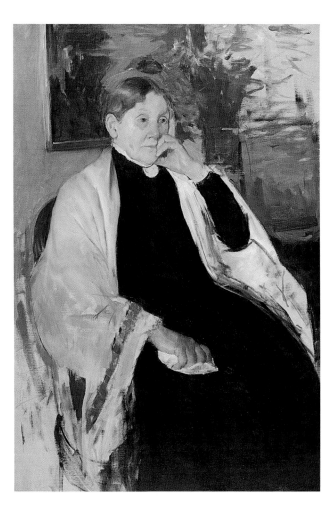

Several times during her long and successful career, Mary Cassatt painted her mother, turning on her the same loving yet scrutinizing eye she employed in her sensitive depictions of mothers and children. The Museums' portrait is the last of these paintings and shows Mrs. Cassatt at about the age of seventy-three. Short, delicate strokes define the sitter's face and hands; the details of shawl, flowers, and background are brushed in with broad strokes of color that contrast with the rich, deep black of her dress. Recalling the work of Edouard Manet and of the circle of French impressionism in which Cassatt thrived, the bold execution counters the reserve of Mrs. Cassatt's reflective pose, and suggests the vitality and vigorous intelligence as well as the tenderness of this strong woman.

ROBERT HENRI (1865–1929)

*Lady in Black with Spanish Scarf
(O in Black with Scarf)*, 1910

Oil on canvas, 77¼ x 37 in. (196 x 94 cm)

Gift of the de Young Museum Society, purchased
from funds donated by the Charles E. Merrill Trust
66.27

Painted two years after their marriage, Henri's portrait of his wife (whom he
called O) ranks among his masterpieces. Cool, elegant, and self-possessed,
O stares directly out of the canvas, her body turned gently to form a sinu-
ous S-curve. The tall, narrow format of the painting accentuates her height,
which is further underscored by the long, vertical sweep of the scarf that
leads to her sensitively modeled face, accented by her full red mouth and
soft red hair.

Henri studied in Philadelphia and Paris during the 1890s, and his early
paintings reflect the tensions between realism and impressionism that those
cities represented. When he moved to New York City in 1900, he began
working in a manner that would lead him to champion a group of emerging
avant-garde artists known as "The Eight." This group, given the popular
name of the Ashcan School, created a visual vocabulary that demonstrated
their commitment to gritty, real-life portrayals of the urban experience.

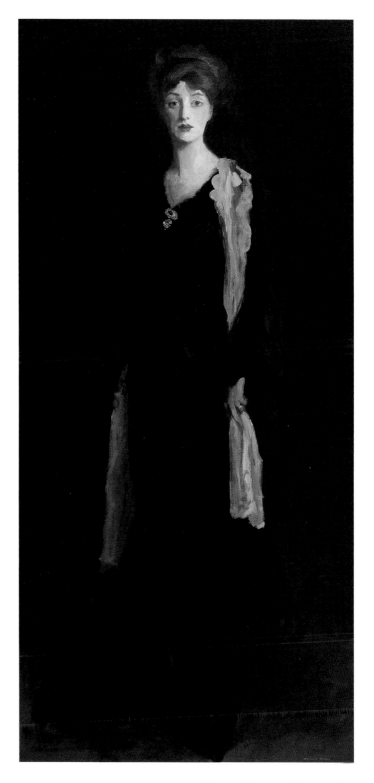

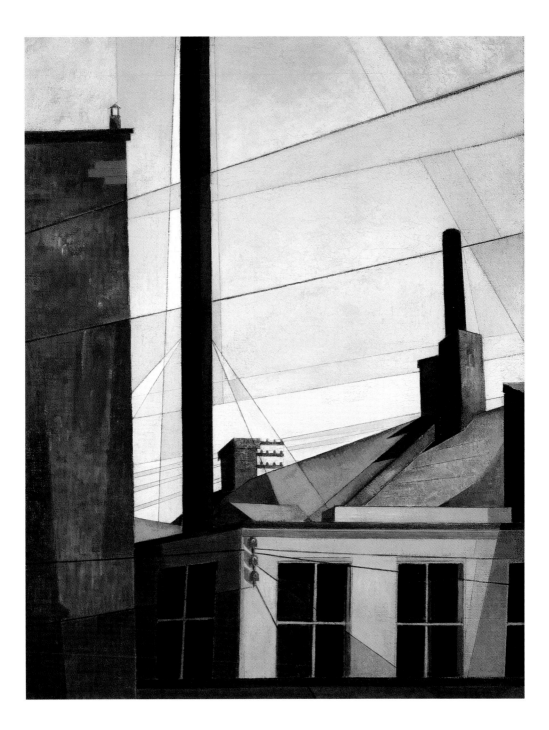

CHARLES DEMUTH (1883–1935)

From the Garden of the Château, 1921
(reworked 1925)

Oil on canvas, 25 x 20 in. (63.5 x 51 cm)

Museum purchase, Roscoe and Margaret Oakes
Income Fund, Ednah Root, and the Walter H. and
Phyllis J. Shorenstein Foundation Fund
1990.4

Charles Demuth's painting *From the Garden of the Château* used a new visual language to celebrate the scientific and technological advancement of the early twentieth century. Americans had been shocked by European avant-garde painting, to which they were introduced at the Armory Show in 1913. The movements of the School of Paris—symbolism, fauvism, cubism, and dadaism, among others—generated hostile responses among the general public as well as more traditional artists and critics. However, during the 1920s, when this work was painted, a number of American artists developed their own approaches to modern representation. These artists, known as precisionists, shared a common interest in urban and industrial themes, which they rendered in a manner that synthesized the principles of avant-garde abstraction and America's longstanding interest in realism. Demuth's cubist-inspired painting depicts the view from his second-floor studio, and, although the buildings and electrical wires present an unremarkable image, he turns them into a radiant, but ironic, ovation to industrial innovation and progress.

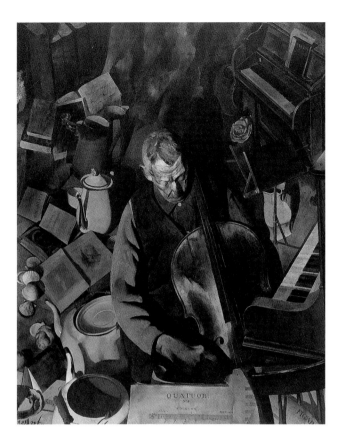

EDWIN W. DICKINSON
(1891–1978)
The 'Cello Player, 1924–26

Oil on canvas
60¼ x 48½ in. (153 x 123 cm)

Museum purchase, Roscoe and
Margaret Oakes Income Fund
1988.5

In *The 'Cello Player*, one of Dickinson's masterpieces, the artist explores the
radical spatial arrangements and seeming monochromaticism of analytical
cubism, while continuing the American tradition of surface-oriented realism.
In wintry gray tones, the painting shows an old man, sitting alone, violoncello
resting against his leg, surrounded by a clutter of books, shells, pots, sheet
music, and instruments. The central focus is the man's head, with its bold
highlights and contoured planes defined by deep furrows. The other realistically
rendered objects are convincing in their form and in the quality of the dim
light falling on them. Yet Dickinson positions each object in a complicated
spatial setting in relation to the sitter. There is a mystery in the composition
that derives in part from these divergent tendencies and from the looming
nature of its personal symbolism, which has been summarized as "a compelling
self-inventory and a poignant memorial to Ludwig van Beethoven (1770–1827)
and . . . to Dickinson's deceased brother Burgess."

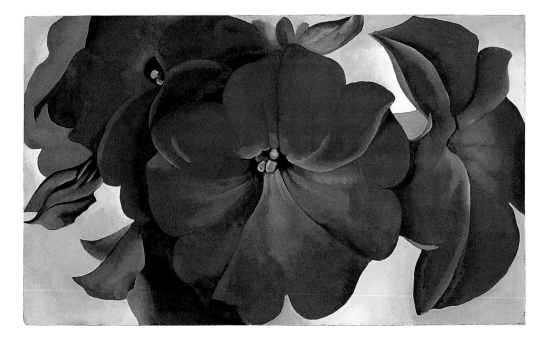

GEORGIA O'KEEFFE (1887–1986)
Petunias, 1925

Oil on hardboard panel, 18 x 30 in. (45.7 x 76 cm)

Gift of the M. H. de Young Family to the Fine Arts
Museums of San Francisco
1990.55

Georgia O'Keeffe is known for her paintings of flowers with intense colors and a
monumental quality, such as *Petunias*. She once declared, "Whether the flower or
the color is the focus I do not know. I do know that the flower is painted large to
convey to you my experience of the flower—and what is my experience of the
flower if not color?" With these rich, saturated hues she infuses flowers with such
vital energy that they assume a greater-than-life presence on her canvases. In these
paintings life does not spring directly from the flowers, but from the shapes, forms,
and colors they inspire in her mind. O'Keeffe brings those personal metaphors
together—not in a literal or realistic way, but with an innovative, modern sensibility,
opening a world of associations, memories, and emotions. She employs the lan-
guage of avant-garde modernism to create the naturalistic effects of the petunias,
painted in intense purple hues, giving them the velvety appearance of delicate and
sensual flowers while transcending realism.

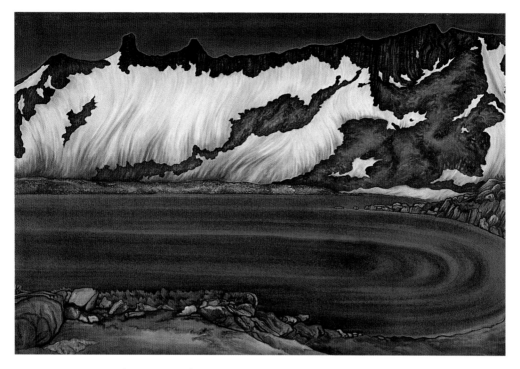

CHIURA OBATA (1885–1975)

Lake Basin in the High Sierra, ca. 1930

Ink and color on silk, 71 x 104⅝ in. (130.3 x 265.8 cm)

Museum purchase, Dr. Leland A. and Gladys K. Barber Fund
2000.71.1

Obata was a prominent practitioner of the modern *nihonga* (Japanese painting) move-
ment, which sought to reconcile traditional Japanese and contemporary European
schools of art, with their focus on naturalism, modeling, and perspective. After leaving
Japan in 1903 and settling in San Francisco, Obata developed a harmonious synthesis
of naturalism and abstraction, incorporating stylized calligraphic delineation, large
areas of subtly modulated color, and a fusion of Japanese and European perspectival
and spatial systems. Through the East West Art Society, which he cofounded in 1921,
he promoted his belief that art and nature could provide the common ground neces-
sary for cross-cultural understanding and the dissolution of the barriers of nationalism
and racism. In his *Lake Basin in the High Sierra*, the luminous, deep blue center of the
lake, painted with sparkling lapis lazuli pigment, perfectly reflects Obata's poetic, Zen-
influenced philosophy of art: "In training and producing art, our minds must be as
peaceful and tranquil as the surface of a calm, undisturbed lake."

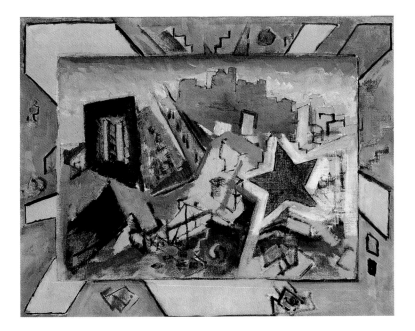

JOHN MARIN (1870–1953)
Study, New York, 1934

Oil on canvas, 22 x 28 in. (55.9 x 71.1 cm)

Museum purchase, Roscoe and Margaret Oakes
Income Fund, and American Art Trust Fund
2002.139

John Marin's extraordinary paintings, watercolors, and prints of New York City, the mountains of New York and New England, the Southwest desert, and the coast of Maine earned him a reputation as one of the most important and influential American artists. He played a key role in assimilating and transmitting European modernism into the American art world, while developing an expressionist style that prefigured many of the innovations of the abstract expressionists. Marin's travels through the art capitals of Europe in 1905–10, a time when fauvism, cubism, orphism, and futurism were gaining notoriety, greatly influenced the evolution of his work. When he returned to New York City, which had been transformed into a modern metropolis dominated by the first skyscrapers, he was struck by its geometric architecture and kinetic street life. *Study, New York* offers a bird's-eye view of the bustling city, as if it were being seen from a skyscraper or an airplane. At the same time the painting also has references to the past: the Native American step motif and muted desert colors of the border recall works inspired by Marin's travels to New Mexico and reflect the interest in Native American culture he shared with his fellow artists Marsden Hartley and Georgia O'Keeffe.

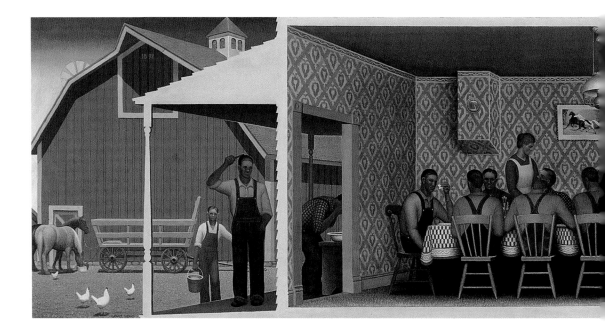

GRANT WOOD (1891–1942)
Dinner for Threshers, 1934

Oil on hardboard panel
20 x 80 in. (50.8 x 203.2 cm)

Gift of Mr. and Mrs. John D. Rockefeller 3rd
1979.7.105

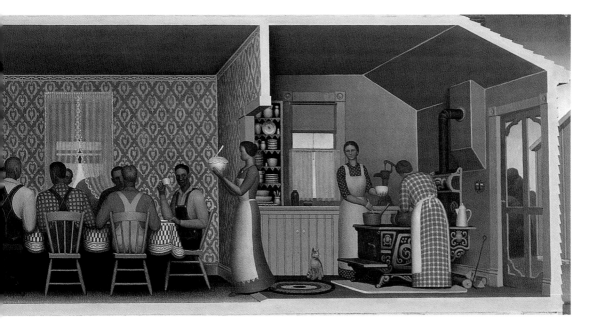

A leading exponent of regionalism, Grant Wood chose to paint in a realist style (based in part on Netherlandish and Italian fifteenth-century paintings), using subjects inspired by his childhood in rural Iowa. One of many works depicting his family and friends, *Dinner for Threshers* represents a ritual of American agrarian life before the days of widespread mechanization—the mealtime gathering of farmers after the grain had been cut and shocked and the threshing machine had arrived. Working cooperatively, the farmers assisted one another in bringing in crops to be processed. Each year a welcome point in threshing day was the midday break, when the workers gathered together for a specially prepared meal. The painting's clarity of contour, meticulous detailing of patterns, and repetition of geometric forms create a decorative surface design characteristic of Wood's mature work. At the same time, the monumental figures and the solemnity and significance of the communal meal, joined with the religious associations of the triptych format, underscore the strength and dignity of American Midwestern life.

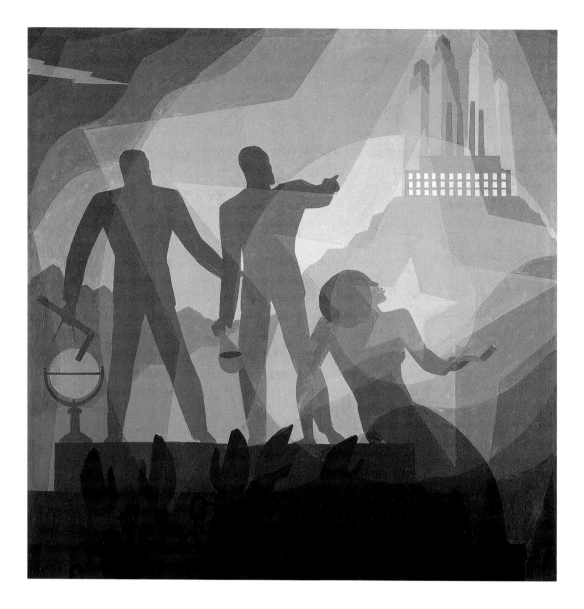

AARON DOUGLAS (1899–1979)

Aspiration, 1936

Oil on canvas
60 x 60 in. (152.4 x 152.4 cm)

Museum purchase, the estate of Thurlow E. Tibbs, Jr., the Museum Society Auxiliary, American Art Trust Fund, Unrestricted Art Trust Fund, partial gift of Dr. Ernest A. Bates, Sharon Bell, Jo-Ann Beverly, Barbara Carleton, Dr. and Mrs. Arthur H. Coleman, Dr. and Mrs. Coyness Ennix, Jr., Nicole Y. Ennix, Mr. and Mrs. Gary Francois, Dennis L. Franklin, Mr. and Mrs. Maxwell C. Gillette, Zuretti L. Goosby, Mr. and Mrs. Richard Goodyear, Marion E. Greene, Mrs. Vivian S. W. Hambrick, Laurie Gibbs Harris, Arlene Hollis, Louis A. and Letha Jeanpierre, Daniel and Jackie Johnson, Jr., Stephen L. Johnson, Mr. and Mrs. Arthur Lathan, Mr. and Mrs. Gary Love, Lewis & Ribbs Mortuary Garden Chapel, Glenn R. Nance, Mr. and Mrs. Harry S. Parker III, Mr. and Mrs. Carr T. Preston, Fannie Preston, Pamela R. Ransom, Dr. and Mrs. Benjamin F. Reed, San Francisco Black Chamber of Commerce, San Francisco Chapter of Links, Inc., San Francisco Chapter of the N.A.A.C.P., Sigma Pi Phi Fraternity, Dr. Ella Mae Simmons, Mr. Calvin R. Swinson, Joseph B. Williams, Mr. and Mrs. Alfred S. Wilsey, and the people of the Bay Area 1997.84

During the 1920s, African Americans created a thriving culture of jazz, theater, literature, and visual art in New York's Harlem district. Known as the Harlem Renaissance, this artistic explosion fostered a cultural community of people who set about celebrating the opportunities of modern urban life in a language that drew inspiration from their common heritages as people of African descent. *Aspiration* is one section of a four-part mural cycle that Douglas created for the "Hall of Negro Life" at the 1936 Texas Centennial Exposition in Dallas. The cycle reflects the optimism among African Americans that lingered well after the halcyon days of the Harlem Renaissance. In this mural Douglas organizes his visual image of African heritage according to a highly rationalized, didactic scheme: the shackled hands reach up in a gesture that links them with the experience of slavery, while the monumental figures represent the transformation from forced labor to a community of modern workers inspired by leaders trained in literature, science, and engineering, as symbolized by the book, beaker, globe, and compass and right angle. As a further celebration of African heritage, Douglas uses an Egyptian-inspired figure and the pictorial conventions of Egyptian representation, which combine frontal and profile images. In this way he unites the flattened, abstract language of avant-garde modernism with a visual vocabulary linked to ancient Egypt and, therefore, African origins.

THOMAS HART BENTON
(1889–1975)
Susanna and the Elders, 1938

Oil and tempera on canvas
mounted on wood panel
60⅛ x 42⅛ in. (152.7 x 107 cm)

Anonymous gift to the California
Palace of the Legion of Honor
1940.104

The subject of Benton's *Susanna and the Elders* is taken from the biblical tale in the
Book of Daniel in which two respected members of the community spy on the
virtuous Susanna and proposition her while she prepares for her bath. Enraged at
her refusal, they falsely charge her with adultery. Only the divinely inspired wis-
dom of the prophet Daniel, who separates the two men and discovers discrepancies
in the perjured testimony, saves Susanna from an unjust death. As a regionalist
artist painting the world around him, Benton has updated the scene, shifting the
locale from Babylon to Missouri and modernizing the trappings of the tale.
Perhaps in part because of this application of the biblical tale to modern times,
and certainly because of the bold nudity of the figure, *Susanna and the Elders*
caused a sensation when the work was exhibited throughout the Midwest and
West in 1938 and 1939.

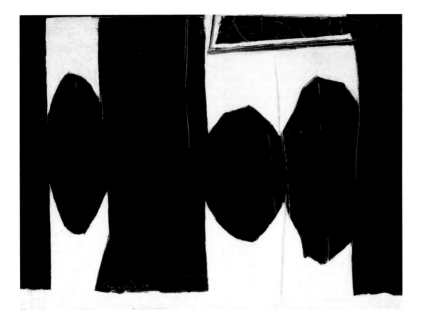

ROBERT MOTHERWELL (1915–1991)
At Five in the Afternoon, 1950

Oil on masonite, 36 x 48 in. (91.4 x 121.9 cm)

Bequest of Josephine Morris
2003.25.4

At Five in the Afternoon is considered to be one of Robert Motherwell's most important
works, representing the first large-scale painting to explore the signature motif of alternating
bars and ovoids in his famous series *Elegies to the Spanish Republic.* This series of more than
100 works introduced one of the most significant and recognizable forms of imagery of
Motherwell's generation, and secured his status as a foremost member of the New York
School. Painting in a style called abstract expressionism, this group of artists rejected familiar
subject matter as mere surface decoration. Influenced by the surrealists, they sought to create
paintings that would represent the more profound truths of psychological experience
beneath visible realities, the unseen forces related to emotion and feeling. Motherwell,
trained in philosophy, was one of the group's most erudite voices for this attempt to capture
abstract concepts and impressions rather than the concrete world. Through the motif of
strong verticals alternating with ovoids in black against a white ground, Motherwell fashions
a symbolic portrait of Spain, his own personal metaphor for the era's ideological contests
over freedom, conformity, social responsibility, and national ambition.

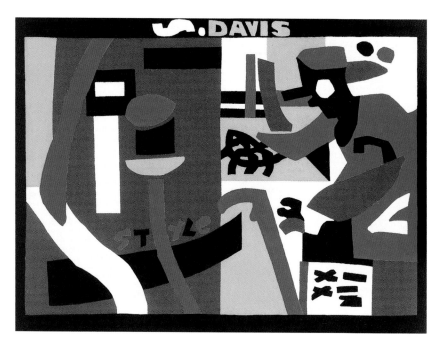

STUART DAVIS
(1892–1964)
Night Life, 1962

Oil on canvas
24 x 32 in. (61 x 81.3 cm)

Gift of Mrs. Paul L. Wattis
and Bequest of the
Phyllis C. Wattis 1991
Trust from Paul L. Wattis, Jr.
and Carol W. Casey
1996.75

Stuart Davis was a major innovator in the development of American modernism and abstraction. He exhibited in the 1913 Armory Show, which introduced European modernism into America, and his work encompassed Ashcan School subjects in the 1910s, the introduction of cubism in the 1920s, WPA public mural projects in the 1930s, kinetic abstractions that anticipated abstract expressionism in the 1940s, and reductive abstractions that prefigured color-field painting in the 1950s. His use of mass-produced images of popular culture contributed to the evolution of an American vernacular aesthetic that was embraced by pop artists in the 1960s. *Night Life* is the culmination of Davis's belief in the importance of jazz, an American art form, to the development of American modernism. His lifelong love of jazz evolved from early representational depictions of jazz-club nightlife to a mature assimilation of jazz theory, sensibilities, and language in works like this one. In *Night Life*, Davis identifies with the jazz pianist as a fellow creator and performer, who improvises variations on a theme through the use of composition, syncopation, color, tone, and harmony.

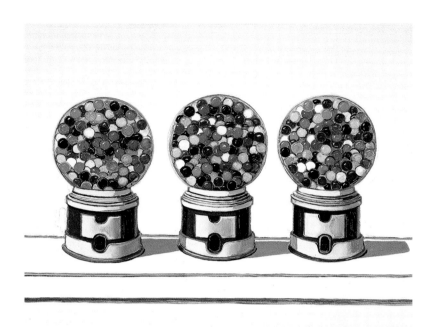

WAYNE THIEBAUD

(b. 1920)

Three Machines, 1963

Oil on canvas, 30 x 36½ in. (76.2 x 92.7 cm)

Museum purchase, Walter H. and Phyllis J. Shorenstein Foundation Fund and the Roscoe and Margaret Oakes Income Fund with additional funds from Claire E. Flagg, the Museum Society Auxiliary, Mr. and Mrs. George R. Roberts, Mr. and Mrs. John N. Rosekrans, Jr., Mr. and Mrs. Robert Bransten, Mr. and Mrs. Steven MacGregor Read, and Bobbie and Mike Wilsey, from the Morgan Flagg Collection 1993.18

Wayne Thiebaud calls himself "an ordinary American kid," a view reflected in his paintings of everyday objects. Throughout his career, he has produced a familiar American world of fluffy cakes, hot dogs, ice-cream cones, ordinary people, bucolic rural land-scapes, and dynamic city views. But his images of food and consumer goods, however, are not ordinary; they are masterfully painted works of art, fittingly done for the most part from memory. Bursting with color and form, this well-known painting of three gumball machines is a snippet of nostalgia, referring to fond memories from Thiebaud's youth and a van-ishing sense of Americana. But, at the same time, the brightly colored objects of desire transcend the ordinary: for the artist they are symbols of hope and possibility, evoking the American Dream, which can be sweet and wonderful.

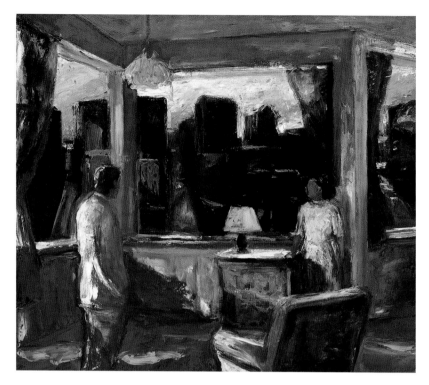

ELMER BISCHOFF (1916–1991)

Yellow Lampshade, 1969

Oil on canvas, 70 x 80 in. (177.8 x 203.2 cm)

Museum purchase, gift of Nan Tucker McEvoy in
memory of her mother, Phyllis de Young Tucker
1992.10

Yellow Lampshade, one of Bischoff's later figurative works, is especially revealing of
his fascination with the act of painting, and the sense of process is strongly felt in
his lush style. This is a painting that glows, projecting the artist's belief that "color
and light are the primary organizational forces." At the same time, the interaction of
the two figures with one another and with their environment—the room and the
city views seen through the windows—provides the potential for narrative. In the
painting a man and a woman face each other across a bright, modern living room
that is pierced by three large picture windows. The lampshade is just off center,
between the figures. The space is enigmatic, and the faceless characters, the uncer-
tain time of day, and the faceting of geometric forms confirm the artist's attempt to
keep the painting's representational and abstract components in a delicate balance.

WILLEM DE KOONING
(1904–1997)
Untitled XX, 1977

Oil on canvas, 80 x 70 in.
(203.2 x 177.8 cm)

Museum purchase, gift of
Nan Tucker McEvoy
2002.1

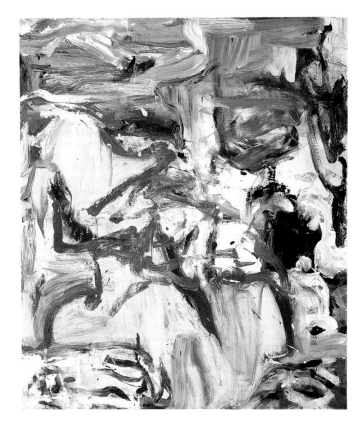

In the late 1940s, more than twenty years after de Kooning emigrated from the Netherlands, he helped to pioneer the artistic movement known as abstract expressionism. One of the most influential and original movements in American art, it drew its inspiration from surrealism, theories of unconscious creation, and existentialist thought. The emphasis is on the artist's vision through abstraction, innovation, process, and intuitive action over rational thought. *Untitled XX* is from a series of late paintings in which de Kooning, at the height of his expressive powers as a painter, explored his favorite subjects—the female nude and the landscape. Although the physicality of the nude is not apparent, her presence is evoked by the sensual and curvilinear rose, pink, and flesh areas that fill the left half of the composition. The sensuousness of the painted skin recalls de Kooning's celebrated comment, "flesh was the reason oil painting was invented." The nude appears to be inextricably embedded in the landscape. Within the energetic flurry of seemingly abstract brushwork, there are elements reminiscent of de Kooning's earlier landscape paintings.

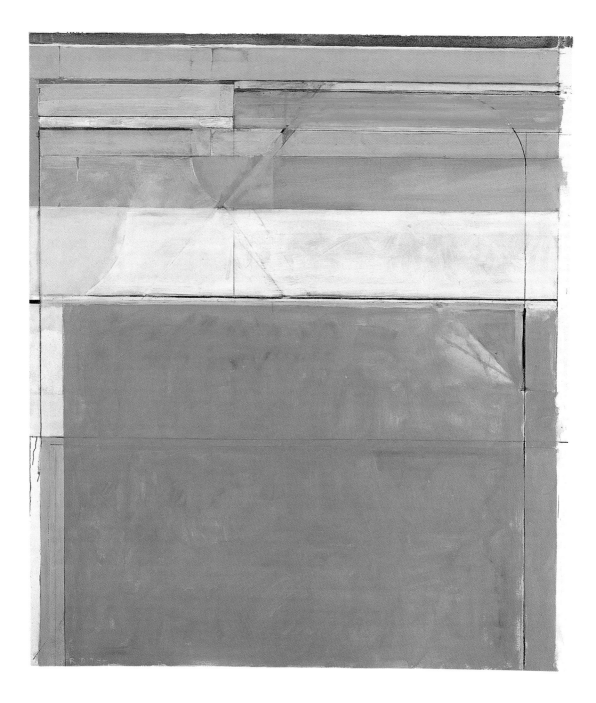

RICHARD DIEBENKORN (1922–1993)
Ocean Park 116, 1979

Oil on canvas, 82 x 72 in. (208.3 x 182.9 cm)

Museum purchase, gift of Mrs. Paul L. Wattis
2000.20

Richard Diebenkorn's *Ocean Park* series represents one of the finest achievements in the history of American abstract art. His exploration of the complexities of abstraction and representation started in the early 1950s, when he began to incorporate overtly representational imagery, prompting critics to describe him as an abstract painter who paints landscapes and figures. He accepted this description with reservations, observing, "all paintings start out of a mood, out of a relationship with things or people, out of a complete visual impression. To call this expression abstract seems to me often to confuse the issue. Abstract means literally to draw from or separate. In this sense every artist is abstract, for he must create his own work from his visual impressions. A realistic or nonobjective approach makes no difference." The *Ocean Park* series, which ultimately included approximately 143 paintings, inaugurated his return to abstraction. The series title was derived from the Ocean Park neighborhood of Santa Monica, where Diebenkorn had a studio from 1966 until 1988.

ED RUSCHA (b. 1937)

A Particular Kind of Heaven, 1983

Oil on canvas, 90 x 136 in. (228.6 x 345.4 cm)

Museum purchase, Mrs. Paul L. Wattis Fund
2001.85

Ed Ruscha is widely recognized as one of the most important and influential American artists of the post-World War II generation. Although his work initially was associated with the pop movement of the 1960s, it increasingly transcended its pop origins and evolved to address issues pertaining to the American landscape tradition, minimalism, and conceptual art. *A Particular Kind of Heaven* is one of a series of related works Ruscha created in the mid-1980s, in which words and phrases are silhouetted against the sky. As they hover over the horizon like a geometric form of skywriting, the flat, emphatic letters dominate the sunset. The painting's large-scale, panoramic format and spectacular light effects relate to a long tradition of American landscape painting, represented by artists such as Martin Johnson Heade (see pp.70–71), Frederic E. Church (see pp. 72–73), and Albert Bierstadt (see pp. 74–75). Ruscha's enigmatic words invite scrutiny and pose the implicit question, "what kind of heaven?" His "particular," personalized heaven is strangely lacking in any visible imagery, suggesting that one must find, or make, one's own vision of heaven and, by association, hell.

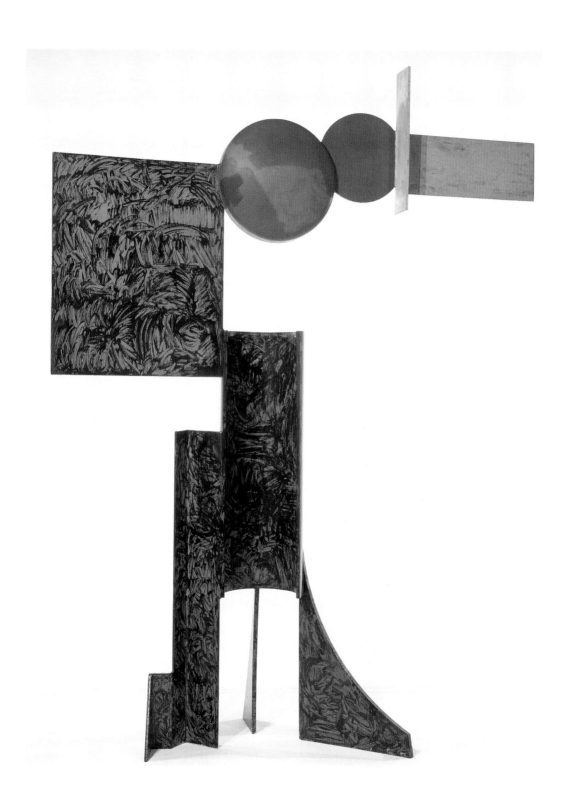

DAVID SMITH
(1906–1965)
Zig V, 1961

Steel and paint
111 x 85 x 44 in.
(282 x 215.9 x 111.8 cm)

Museum purchase, gift of
Mrs. Paul L. Wattis
1999.66

David Smith is generally regarded as one of America's most important sculptors. Borrowing from the cubist and constructivist traditions of welded metal sculpture in European art, Smith was able to give to these techniques a new robustness and greater diversity of form and expression. He was a friend to many of the painters in the abstract expressionist movement, and his work is often thought of as a three-dimensional equivalent to the monumentality and gestural style that characterize the art of that group. This nearly ten-foot-high welded and painted construction dates from the early 1960s, the culminating years of Smith's career, when his work reached a new peak of large-scale, powerful, and dynamic compositional invention. *Zig V* belongs to a series of eight numbered sculptures that Smith hand painted, often with bright colors, works that introduce a new degree of monumentality and movement. Although its title refers to ancient Mesopotamian ziggurats, the sculpture's tripod base and cantilevered composition suggest a standing figure, perhaps a dancer, reaching out into space. Despite its thrusting forms, it is remarkable for its qualities of poise and balance.

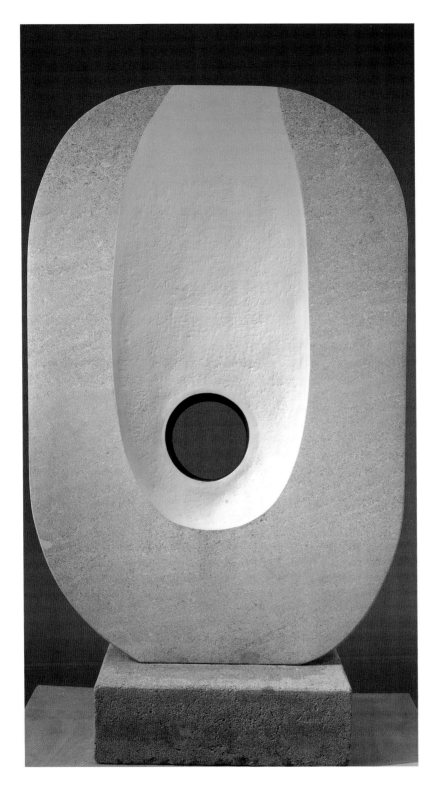

BARBARA HEPWORTH (1902–1975)
Pierced Monolith with Colour, 1965

Roman stone and paint, 68½ x 46 x 8 in.
(174 x 116.8 x 20.3 cm)

Foundation purchase, gift of Barbro and
Bernard A. Osher
2003.110

Dating from the mid-1960s, *Pierced Monolith with Colour* revisits formal challenges Barbara Hepworth had first explored in the 1930s and 1940s, including piercing and applied color. In concepts such as piercing a sculpture, Hepworth, a significant force in art, at times anticipated the work of Henry Moore. *Pierced Monolith*, reminiscent of ancient standing stones in Britain and Europe, was carved for her own sculpture garden and was still in her collection at the time of her death. Elegant and refined, this structure embodies the artist's distinctly personal and intelligent emphasis on monumental, simplified, and abstracted curving forms that evoke organic shapes from the natural world. Her sophisticated treatments of the surfaces focus attention on the stone's texture. The pale blue pigment applied to the interior of the carving suggests that, in its outdoor setting, Hepworth looked upon this work as engaging in a constantly changing dialogue with the sky.

PETER VOULKOS (1924–2002)
Yogi, 1997

Stoneware, 46 x 32 x 25 in.
(116.8 x 81.3 x 63.5 cm)

Partial gift of Dorothy and George
Saxe to the Fine Arts Museums
Foundation
2002.148.51

Peter Voulkos created ceramics whose form, content, and scale have challenged
traditional definitions of sculpture. By emphasizing process, performance, and
expression he produced unprecedented large-scale, glazed and painted ceramic
works that transcend the boundaries between painting, sculpture, and pottery.
Revealing their debt to abstract expressionism and the teachings of Zen
Buddhism, his sculptures focus on means rather than ends, an embracing of
chance and accident, and an understanding of the potential of the calligraphic
gesture. *Yogi*, one of Voulkos's "stack" sculptures, is composed of irregular cylin-
drical components stacked and fused together with clay and slip. Inspired in
part by the eroded landscape of his native Montana, it also resembles an ancient
architectural form that has crumbled away to reveal the cruder, underlying
structure beneath.

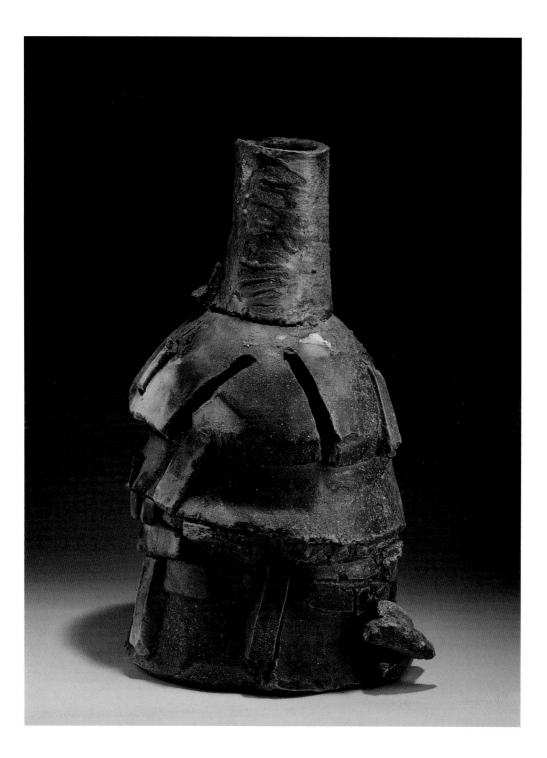

CLAES OLDENBURG
(b. 1929) **AND**

COOSJE VAN BRUGGEN
(b. 1942)
Corridor Pin, Blue, 1999

Stainless steel, aluminum,
and polyurethane enamel
255 x 254 x 16 in.
(647.7 x 645.2 x 40.6 cm)

Foundation purchase, gift of the
Barbro Osher Pro Suecia Foundation
2003.66a–b

Claes Oldenburg is widely acknowledged as one of the most important and influential sculptors of the post–World War II generation. Although often hailed as a pioneering figure associated with the pop art movement, in recent years, working in partnership with the curator, critic, and art historian Coosje van Bruggen, Oldenburg has focused on the creation of large-scale public sculptures. *Corridor Pin, Blue* takes as its subject a common, utilitarian household or workplace object so prosaic that it typically goes unnoticed. Like Georgia O'Keeffe's two-dimensional flower still lifes, Oldenburg and van Bruggen's three-dimensional sculptures achieve much of their startling impact through selection, isolation, simplification, and magnification of the subject. Here the scale is enlarged by a factor of 250, and the pin is balanced vertically in a manner impossible to achieve with its real-life counterpart. By creating a safety pin that can no longer be used in practical terms, Oldenburg and van Bruggen shift attention away from the object's function, focusing instead on its formal and sculptural properties. The result is an elegant minimalist sculpture that elevates a banal subject into the realm of fine art.

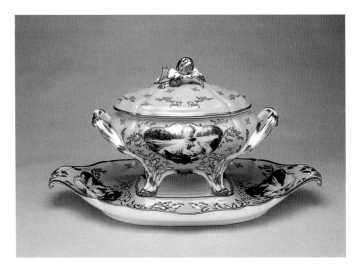

CINDY SHERMAN (b. 1954) AND LIMOGES, ANCIENNE MANUFACTURE ROYALE

Soup Tureen on Platter (Madame de Pompadour née Poisson [1721–1764]), 1986

Handpainted and photosilkscreened porcelain
14½ x 22 x 11¾ in. (36.8 x 55.9 x 29.8 cm)

Museum purchase, Dorothy and George Saxe
Endowment Fund
2002.8a–c

Cindy Sherman's reputation as an artist was made in 1979 when she exhibited her now legendary "Film Still" photographs. In these black-and-white photos, reminiscent of movie stills and magazine images from the 1950s and 1960s, she took on the identity of stock heroines of the postwar screen—especially the sweethearts and sex symbols Doris Day, Natalie Wood, Marilyn Monroe, and Brigitte Bardot. Her artistic expression follows her enjoyment of playing with clothes, props, and even identities. By appropriating the wardrobe, backdrops, and special effects, which add veracity to her "celebrity" portraits, Sherman takes on the dual role of artist and subject. In 1988, she was invited to work at the Limoges porcelain factory, where she transformed a traditional Sèvres porcelain service that had been created in 1756 for the infamous Madame de Pompadour, mistress of Louis XV. In her tongue-in-cheek artistic style, Sherman had the Limoges ceramists duplicate the curvy rococo form of the tureen from this service, replacing the painted portraits of Pompadour that adorned the tureen and its tray with photographs of herself in a gown and a wig of silver curls. She also reshaped leaves into fish, a reference to Pompadour, whose family name was Poisson, French for fish.

UNIDENTIFIED ARTIST
Philadelphia, Pennsylvania
High Chest of Drawers, ca. 1780

Mahogany, pine, and poplar
91 x 43¾ x 22⅝ in.
(231.1 x 111.1 x 57.5 cm)

Museum purchase, gift of
Mr. and Mrs. Robert A. Magowan
77.2

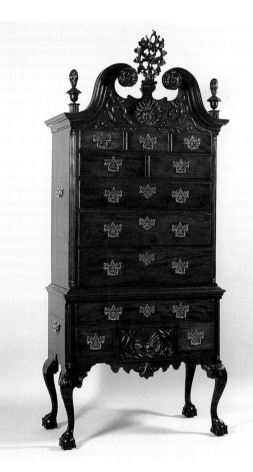

The remarkable high chests of drawers produced by Philadelphia cabinetmakers and carvers mirror the self-confidence, sophisticated taste, and mature accomplishment of that city's artisans and patrons in the period immediately before and after the American Revolution. Characterized by highly figured and richly grained woods, crisp carving, elegant proportions, and imposing architectural details such as pediments, they rank among the finest examples of American cabinetwork of the eighteenth century. Usually made with companion dressing tables, these high chests retained the basic form of their graceful Queen Anne antecedents, but the selective incorporation of elements of the rococo, which Thomas Chippendale called the "modern" style, resulted in a distinctive American expression that had no parallel in English furniture. Traditionally known as "Bathsheba Hartley's high chest," this piece was made for Benjamin Hartley. His daughter Bathsheba married John Brick in 1789, and the chest descended in the Brick-Deacon family.

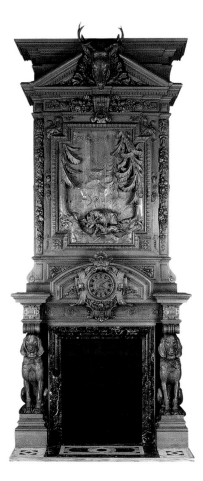

HERTER BROTHERS, NEW YORK, RETAILER
GUÈRET FRÈRES, PARIS, MAKER
Mantelpiece for Thurlow Lodge, Menlo Park, California, ca. 1872–73

Wood, marble, and clock, 168 x 72 in. (425.7 x 182.9 cm)

Gift of James George and Penny Coulter
2001.33

This extraordinary hand-carved mantelpiece was created for United States Senator Milton S. Latham's Menlo Park mansion, Thurlow Lodge, one of the San Francisco Bay Area's most famous Gilded Age homes. A monument to French neoclassical Second Empire style, the home's interior design and furnishings were commissioned from America's premier decorator firm, Herter Brothers, based in New York but with a retail outlet in San Francisco. Herter Brothers in turn commissioned the mantelpiece from the respected Parisian firm of Guèret Frères, which was known for its exceptional woodcarving. The principal decorative elements of this mantelpiece, the centerpiece of Thurlow Lodge's lavish dining room, are a pair of fully carved, sentinel-like hunting dogs, a high-relief overmantel scene in which the dogs attack a wild boar, and a carved buck's head finial. Such scenes harken back to the decoration found in aristocratic European Renaissance and baroque hunting lodges.

UNIDENTIFIED ARTIST
Probably Espanosa or Marena,
New Mexico
*La Carreta de la Muerte
(Chariot of Death Carrying the
Angel of Death)*, ca. 1900

Pine, cottonwood, paint, horsehair,
marbles, leather, paper, and fabric
costume, 41 x 21 x 50 in.
(104.1 x 53.3 x 127 cm)

Gift of The Haley Family Trust
1995.28a–d

This death cart and figure were found in the vicinity of Taos, New Mexico, close
to the Penitente center of Truchas. The Penitente Brotherhood is a centuries-old
Catholic order whose secret rituals marking the death and resurrection of Christ
represent some of the oldest continuously practiced religious rituals in the United
States. For this order, Easter Holy Week observance inspired the most profound
public expressions of penance for their sins and wrongdoings. Reenacting the
scenes of the passion of Christ, they marched from the *morada*, or Penitente
chapter house, to a site representing Calvary. In these processions, death was
given a powerful presence as a haunting image of a human skeletal figure, made
even more realistic by the addition of hair, glass eyes, individually carved teeth,
and moveable limbs. This figure and cart show the signs of age and wear that
support the claim that it was used in the Penitente ritual.

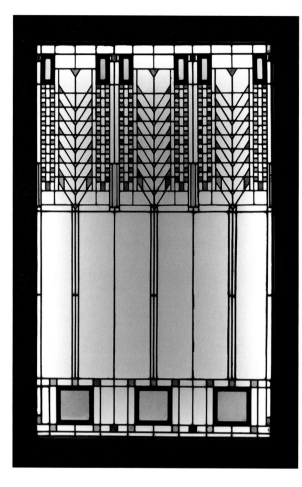

FRANK LLOYD WRIGHT

(1869–1959)
Tree of Life Window
Executed by the Linden Glass
Company, Chicago, Illinois, 1904

Clear, colored, and iridescent glass
with copper-coated zinc caming
47½ x 32⅜ in. (120.7 x 82.2 cm)

Gift of Mrs. Darwin Martin
1982.70

Considered Wright's finest window design from his Prairie School period, the
Tree of Life windows were installed in the remarkable complex of buildings
designed as the residence of D. D. Martin and constructed in Buffalo, New York,
in 1904. In this complex, which encompassed a main house, greenhouse, garage,
and a smaller house for Martin's sister and brother-in-law, Wright achieved one
of his most unified and harmonious projects. Martin, an executive of the Larkin
Soap Company, for which Wright also designed the company administration
building, was a lifelong friend. He allowed the architect total freedom in the
project. In addition to the windows Wright also designed the furniture, lighting
fixtures, and table lamps, and he advised the Martins in the collection of Japanese
prints and ceramics for display in the house. The geometric abstraction of the
tree motif, a theme that has its origin in antiquity, visually integrated the archi-
tectural forms of the house with the natural environment of its site.

CHARLES SUMNER GREENE
(1868–1957) **AND HENRY MATHER
GREENE** (1870–1954), **DESIGNERS
PETER HALL MANUFACTURING
COMPANY** (1906–22),
PASADENA, FABRICATORS
*Sidechair for the Robert R. Blacker
House, Pasadena, California*, 1907

Mahogany, ebony, copper, pewter, coral,
mother-of-pearl, 42 x 17¾ x 17¾ in.
(106.7 x 45.1 x 45.1 cm)

Museum purchase, the Decorative Arts
Endowment Fund, the Decorative Arts
Fund, the Atholl McBean Foundation, the
Friends of Ian White Fund, the Bequest of
Joseph G. Bradley Jr., and the Estate of
Alma Bernheim in memory of Jules H.
Bernheim and Alma Bernheim
1993.120

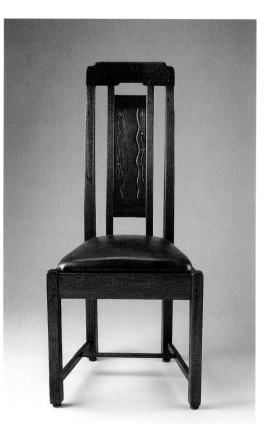

Furniture designed by Greene and Greene is widely recognized as being the
highest achievement of the California arts and crafts movement. Among
the finest examples of their work was the house and interior designed for Robert
R. Blacker, built in 1907 in Pasadena's prestigious Oak Knoll subdivision. The
furniture for this house is some of the most important by a twentieth-century
maker, revealing the beautifully detailed mortise-and-tenon joins, a sophisticated
use of luxurious materials, highly finished surfaces, and design inspiration from
Japan. This dining-room chair, one of a set that included two armchairs, is
constructed of the same material components and displays the fine craftsmanship
that distinguished the interiors of the Blacker house, which was paneled in teak
and mahogany with peg detailing in ebony and mahogany. The use of mother-of-
pearl inlay on this chair characterizes Greene and Greene's designs and reflects
the architects' sensitivity to Japanese influence.

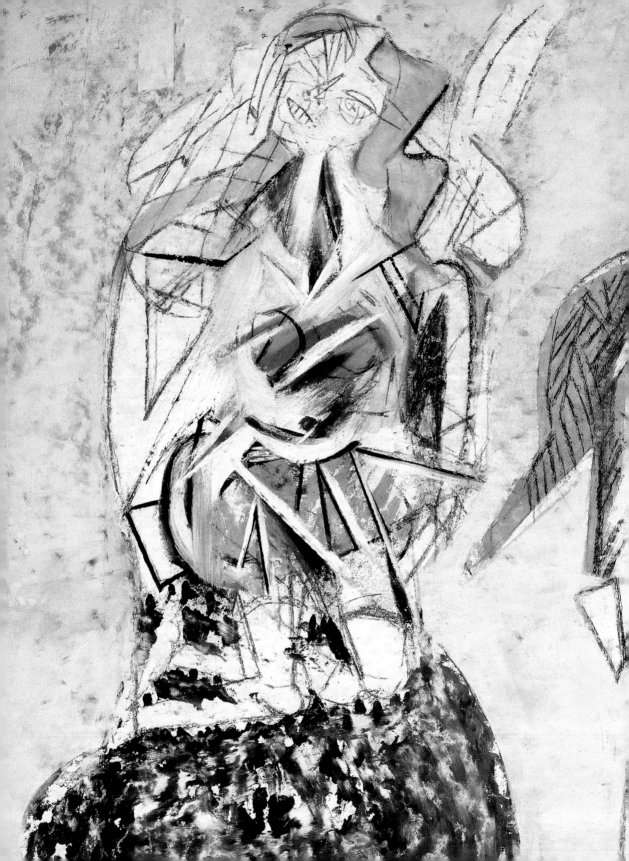

Works of Art on Paper

JOHN JAMES AUDUBON
(1785–1851)
Douglass' Squirrel, a study for pl. 48 of *Viviparous Quadrupeds of North America* by John James Audubon and the Reverend John Bachman (New York: John James Audubon,1845–48), ca. 1843

Watercolor, ink, graphite, and glaze on wove paper
12³⁄₁₆ x 9½ in. (31 x 24.2 cm)

Gift of Mr. and Mrs. John D. Rockefeller 3rd
1979.7.5

John James Audubon, perhaps the most famous of American ornithologists, is less well known for his work depicting the *Quadrupeds of North America.* With the success of his *Birds of America,* Audubon was inspired to do the same type of publication on mammals. This resulted in his final great project, the publication of a three-volume folio edition illustrating 150 species, published between 1845 and 1848. As with the work on birds, this volume was later issued in octavo size, making it more accessible to the general public. Audubon did preparatory watercolors for the lithographs that appeared in this publication, and these original drawings and watercolors reveal his technical prowess and his talent for revitalizing dead specimens. Over the years Audubon had developed a style of drawing in pencil, pen, and watercolor that not only carefully describes a bird or animal, but also gives a remarkable impression of its energy and wild spirit. This drawing of the Douglass' or Chickaree squirrel reveals the sensitively rendered fine coat and alert pose of the animal painted by an artist and naturalist who spent much time studying fauna in their natural environment.

MARY CASSATT (1844–1926)

*Woman Bathing
(La toilette)*, 1891

Color aquatint and drypoint, Br. 148 v/v,
14⅜ x 10½ in. (36.5 x 26.6 cm) (image)

Museum purchase, Achenbach Foundation
for Graphic Arts Endowment Fund and
William H. Noble Bequest Fund
1980.1.8

In the spring of 1890 the Ecole des Beaux-Arts in Paris presented a large exhibition of Japanese woodblock prints *(ukiyo-e)*. The works in this show, especially those of Kitagawa Utamaro (1753–1806), had a profound effect on the American impressionist artist Mary Cassatt. Although already an innovative and original printmaker, during the following year she produced her extraordinary series of Japanese-inspired color prints, employing the techniques of drypoint and color aquatint. Loosely based on aspects of Japanese prints she had seen in Paris, her new work was technically sophisticated and complex. *Woman Bathing*, a landmark in the history of color printmaking, demanded multiple plate printing with careful registration from one color to the next. The delicately colored print is in the large *oban* format favored by Utamaro and contains a "tea green" tone she had seen in the Japanese prints.

WINSLOW HOMER (1836–1910)
Sunrise, Fishing in the Adirondacks, 1889

Watercolor on wove paper
14 x 21 in. (34.3 x 52.2 cm)

Museum purchase, Mildred Anna Williams Fund
1966.2

Winslow Homer was a private, even reclusive, man with two great passions: he loved to paint and he loved to fish. Painting was his life's work and fishing was a hobby that he shared with other passionate anglers. When he brought his vocation and avocation together, the result was a remarkable series of watercolors that are among the finest of their day. In 1889 Homer was elected to a private sportsmen's club in New York's Adirondack Mountains, and he fished there on two extended visits. Those lengthy stays inspired extraordinary watercolors that he exhibited the following year in New York City. This work was among them. Under a brilliant red sky, a lone angler stalks a trout. The long line he casts is aimed at the white ripple on the far right where a fish has just risen to the surface. Homer's Adirondack watercolors won both critical and popular acclaim, and within two weeks he had sold all but three of those in the exhibition.

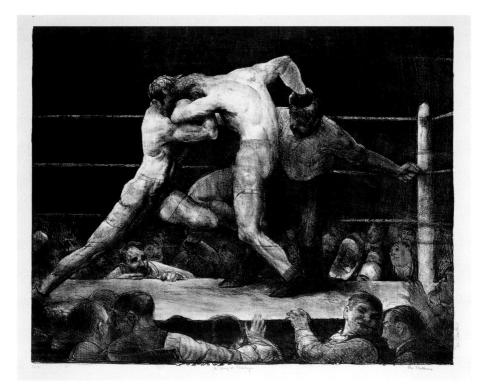

GEORGE WESLEY BELLOWS (1882–1925)
A Stag at Sharkey's, 1917

Lithograph, M. 46, 18½ x 23⅞ in. (47 x 60.6 cm) (image)

Museum purchase, Achenbach Foundation for Graphic Arts Endowment Fund
1966.80.55

One of America's most dynamic realist artists, George Bellows chose painting over a career as a professional baseball player. Sports, however, continued to interest him and provide subjects for his work. This lithograph, taken from his earlier painting of the same name, shows a fight at Tom Sharkey's Athletic Club, a popular entertainment bar, located directly across the street from the artist's studio in New York City. Fierce boxing matches took place there in a small room, with the spectators crowded close to the ring in a noisy atmosphere filled with cigar smoke and the pungent smells of beer and sweat. The contenders, who seem closely matched, are the powerful focal point for the print. Bellows was inspired by Robert Henri and became a junior member of a group of artists who painted blunt and harsh scenes of rugged urban life, the realism of which earned them the nickname the "Ashcan School." He captured gritty city types in his paintings, drawings, and lithography.

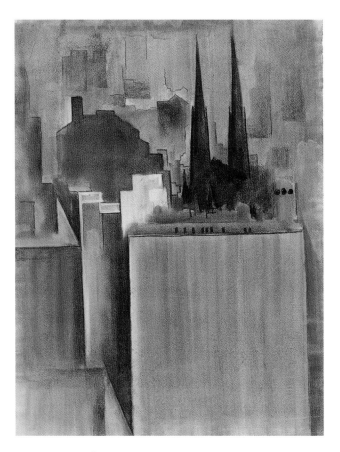

GEORGIA O'KEEFFE (1887–1986)
Untitled (New York), ca. 1925–30

Charcoal on laid paper, 24½ x 18¾ in. (62.3 x 47.6 cm)

Gift of Charlotte S. Mack
1961.48.1

From 1918 until 1928 Georgia O'Keeffe lived and worked principally in New York City. In 1924 she and her husband, the photographer and gallery owner Alfred Stieglitz, moved into an apartment on the thirtieth floor of the Shelton Hotel, overlooking Lexington Avenue between 48th and 49th Streets, where O'Keeffe set up a studio. From her studio window she painted and drew many scenes of the city. This highly controlled yet abstracted composition, executed in charcoal for a velvety surface, illustrates the dynamism of the city by its contrast of light and dark and by the straightforward rendering of formal and flat shapes that make up the various components of the skyline.

FRIDA KAHLO (1907–1954)

El Aborto (Frida and the Miscarriage), 1932

Lithograph, 8¾ x 5⁹⁄₁₆ in.
(22.2 x 14.2 cm) (image)

Museum purchase, Dr. R. Earl
Robinson Estate and Achenbach
Foundation for Graphic Arts
Endowment Fund
1996.38

It is impossible to separate the life and work of the Mexican artist Frida Kahlo—her art is her biography. Following a crippling traffic accident, she turned her attention from a medical career to painting in order to express her emotions on the canvas. She painted her anger and hurt over her stormy marriage with the Mexican muralist Diego Rivera, her miscarriages, and the physical traumas she underwent as a result of the accident. Drawing on personal experiences, her works are often shocking in their stark portrayal of pain and the harsh lives of women. Fifty-five of her 143 paintings are self-portraits that incorporate personal symbolism, complete with graphic anatomical references. *El Aborto* of 1932 is the only significant print she ever made. It was created in Detroit, where she used a lithography workshop in an arts and crafts guild to help her combat depression after she suffered the first of her three miscarriages. One of only six known impressions, this work is quintessential Kahlo, a self-portrait dealing directly with a difficult aspect of her life.

WILLEM DE KOONING (1904–1997)
Untitled (Two Figures), ca. 1947

Oil, watercolor, charcoal, and graphite on wove paper
22½ x 22 in. (57.2 x 55.9 cm)

Museum purchase, gift of Mrs. Paul L. Wattis
1999.131

Willem de Kooning was one of the major figures of the post–World War II abstract expressionist movement. He was born in Rotterdam, Netherlands, and studied art and design before coming to the United States, where he supported himself as a house painter, commercial artist, window display designer, sign painter, and carpenter. *Untitled (Two Figures)* was created at a critical moment in de Kooning's career, when he was reconciling and fusing the figurative and abstract elements of his style. The image consists of a man in an orange suit standing next to a woman in a multicolored dress. The male figure's stiff, manikinlike appearance is contrasted by the fractured, expressively rendered figure of the woman, leading to speculation that this pairing of motifs may have personal significance in terms of de Kooning's conflicted attitude toward women, and that the male figure might well be seen as a self-portrait. His depiction of male manikins and his comment that they were inspired by the sight of "men standing in the subway like manikins" lends credence to the interpretation that they represent the isolation of urban dwellers.

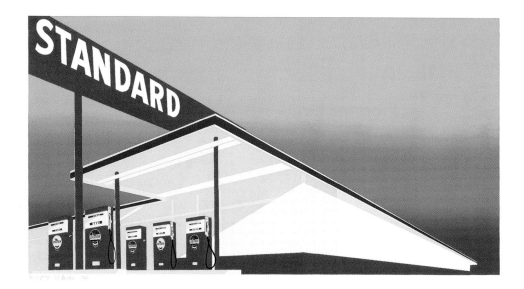

ED RUSCHA (b. 1937)
Standard Station, 1966

Color screenprint, 25⅝ x 40 in. (65.1 x 101.6 cm) (sheet)
Printer: Art Krebs
Publisher: Audrey Sabol

Museum purchase, Mrs. Paul L. Wattis Fund
2000.131.5.1

Ed Ruscha is one of contemporary art's most significant graphic artists. From his first prints to his most recent projects, he has created works that are uniquely American in subject and sensibility. His paintings and prints blend pop, surrealist, and conceptual ideas with his signature sense of deadpan humor. Ruscha discovered that the ideas used in one medium could be translated into another when he transformed *Standard Station, Amarillo, Texas* (1963) into this screenprint image. He reproduced the qualities of the painting by breaking down its foreground and background into separately stenciled screens. To achieve the background, which blends bright blue with orange, Ruscha pulled the different pools of colored ink across the stencil through a screen mesh until the colors bled together. Constantly inventive, Ruscha continues to work with intriguing combinations of picture and language in both prints and paintings (see pp. 104–105).

JASPER JOHNS (b. 1930)
Figure 7, from the Color
Numeral Series, 1969

Color lithograph
27⅛ x 21⅜ in.
(68.9 x 54.3 cm) (image)
Printer: Charles Ritt
Publisher: Gemini G.E.L.

Anderson Graphic Arts Collection,
gift of the Harry W. and Mary
Margaret Anderson Charitable
Foundation
1996.74.211

Numerals, as well as flags and targets, are among the emblematic images that Jasper Johns has used from the beginning of his career as a painter. They were also early subjects in his prints. These iconic symbols are so common as to be registered by the mind almost without thought, and Johns describes them as "things the mind already knows." But, by manipulating them, he turns simple symbols into concrete objects with complicated surfaces that belie their elementary forms. This subtle transformation challenges the viewer to look at something ordinary and easily recognizable in a new way. *Figure 7*, from a series of prints with representations of numerals (0–9), is a self-contained work of art, although part of a larger unit. It includes an equally iconic version of the "Mona Lisa," alluding to Leonardo, who greatly interests Johns, and an imprint of Johns's own hand. He structured the group of ten prints according to color, and this print, made of purple, red, and orange, was signed by the artist in purple, the top color.

RICHARD DIEBENKORN
(1922–1993)
Green, 1986

Color aquatint, spit-bite
aquatint, soap-ground
aquatint, and drypoint
45 x 35¼ in.
(114.5 x 89.4 cm) (image)
Printer: Marcia Bartholme
Publisher: Crown Point Press

Crown Point Press Archive,
gift of Crown Point Press
1991.28.1274

Though he is more widely known as a painter than a printmaker, Richard Diebenkorn's prints are as distinguished as his paintings. In fact, many of his prints are often comparable with his paintings. *Green*, for example, his largest color aquatint, required seven plates and the assistance of five printers working periodically for several months to print the edition, with its lush, luminous colors and painterly detail. Diebenkorn went back into the plates again and again to build up layers of texture and color, and sometimes to change completely whole sections. It is considered by many to be the artist's masterpiece of printmaking. His career spanned some four decades and culminated with his distinction as one of America's preeminent abstract artists (see pp. 102–103). Often turning to printmaking when he had exhausted himself in painting and wanted to search for another possibility, he worked through formal and thematic ideas in his prints that also appear in his earlier and sometimes later paintings.

JAMES MONTGOMERY FLAGG
(1877–1960)
I Want You, 1917

Color lithograph poster
40⅜ x 29⅞ in.
(101.5 x 76.1 cm) (image)

Gift of Darwin Reidpath Martin
1977.1.82

Originally published as the cover for the 6 July 1916 issue of *Leslie's Weekly*—with the title "What are you doing for preparedness?"—this portrait of "Uncle Sam" became, according to the artist James Montgomery Flagg, the most famous poster in the world. More than four million copies were printed between 1917 and 1918, as the United States entered World War I. Because of its overwhelming popularity the image was later adapted for use in World War II. When Flagg presented the poster to President Franklin D. Roosevelt, the artist remarked that he had been his own model for Uncle Sam to save the modeling fee. To this the president replied, "Your method suggests Yankee forebears." Countless parodies of the image attest to its status as a highly recognizable icon.

RUPERT GARCIA (b. 1941)
*Free Nelson Mandela
and All South African
Political Prisoners*, 1981

Color offset lithograph poster, E. 83,
22½ x 17½ in. (57.1 x 44.5 cm) (image)
Published by the Liberation Support
Movement and the United Nations
Centre Against Apartheid

Gift of Mr. and Mrs. Robert Marcus
1990.1.155

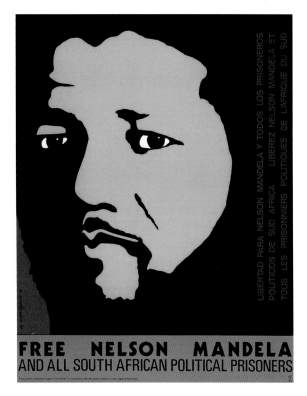

Rupert Garcia is well known for his politically charged posters. His early work was primarily in the medium of silkscreen poster art, in which he developed a unique and colorful style of portraiture. From the beginning of his career, he expressed a commitment to the democratic and nationalist ideals of the Chicano Movement and created images in solidarity with other civil rights and liberation movements, especially those in Indochina, Cuba, Native American communities, and, as in this example, South Africa. Early on Garcia developed his poster trademark—the face seen so close up that its outer edges have vanished. Nelson Mandela, the political leader imprisoned for more than twenty years for his anti-apartheid activities, stares intensely from the background in this powerful image. While deceptively simple, Garcia's works are loaded with emotional impact, triggering associations that are deeply rooted in late-twentieth-century history.

MARTIN PURYEAR (b. 1941)
Cane by Jean Toomer
(San Francisco: Arion Press, 2000)

Cover size: 13¾ x 15⅛ in. (34.9 x 38.4 cm)
Images: 10 woodcuts on Japanese
handmade Kitakata paper; text on German
mouldmade Biblio paper
Images shown: a) Box, 1⅞ x 15¹/₁₆ x 13¹¹/₁₆ in.
(4.8 x 38.3 x 34.8 cm); b) "Karintha," 10⅜ x 12¾ in.
(26.5 x 32.5 cm) (image)

Museum purchase, Reva and David Logan Collection of
Illustrated Books, Artist Book Council and Reva and
David Logan Funds, and Fine Arts Museums Auction Proceeds
2001.91.1–17

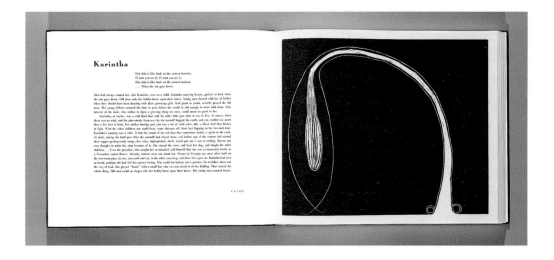

With his innovative sculptures, Martin Puryear has become one of the most distinguished and influential American artists of our time. His abstract yet suggestive woodcuts for this illustrated book superbly complement Jean Toomer's *Cane*, a passionate and evocative collection of stories, poems, and sketches about black life in rural Georgia and the urban North. Toomer's 1923 book, considered the literary masterpiece of the Harlem Renaissance, had been an important work to Puryear since the early 1970s when he taught at Fisk University in Nashville, Tennessee, and experienced what it meant to be an African American living in the South. His series of ten prints developed for the new edition was challenging for Puryear, who found working in two dimensions difficult. He reworked the woodblocks several times until he was satisfied that his abstract woodcut portraits captured the spirit of each character and had the linear grace and refined simplicity of his sculptures. The deluxe edition of the book is contained in a constructed wood box that functions as a sculptural form.

CIRCLE OF THOMAS EAKINS (1844–1916)
Walt Whitman, 1884

Platinum print, 3¼ X 4½ in. (8.3 x 11.4 cm)

Museum purchase, Prints and Drawings Art Trust Fund
1999.127

Walt Whitman, arguably America's most influential and innovative poet, was photographed in the early 1880s by Thomas Eakins, who had recently begun photographing friends, family, and students at the Pennsylvania Academy of the Fine Arts where he taught and was the director. The use of photographs as a teaching tool was common in Europe at this time, and Eakins probably became interested in photography while studying at the Ecole des Beaux-Arts in Paris in the late 1860s. He was taken to visit Walt Whitman for the first time at his home in Camden, New Jersey, by their mutual friend the Philadelphia journalist Talcott Williams. Whitman generally refused to pose for photographers, but, because of his respect for Eakins's artistic skill and educational beliefs, he made an exception. This is one of the most famous photographs of the great poet. Long thought to be by Eakins, recent scholarship suggests that it was either by him or by another artist in his immediate circle who had gained access to and the confidence of Whitman.

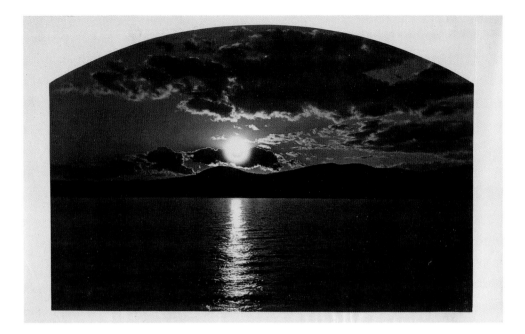

CARLETON E. WATKINS (1829–1916)
Lake Tahoe, from the Warm Springs, ca. 1878

Albumen print, 4½ x 6⅝ in. (11.5 x 16.9 cm) (image)

Museum purchase, Francis Tullis and Reginald
Leighton Vaughan Memorial Fund, gift of
Reginald Bethune Vaughan
1991.3.6

At twenty-one, Carleton Watkins left New York and headed out to California to make his fortune. After working as a daguerreotype operator, he established his own studio in San Francisco and soon made his first photographic expedition to the Yosemite Valley. In 1865 he became the official photographer for the California State Geological Survey, creating some of the first and most important photographs of wild and remote regions. In both stereoscopic and the new mammoth-plate formats, he searched for ways to bring the recently opened American West alive to those unable to experience it firsthand. He lined his Yosemite Art Gallery in San Francisco with large, breathtaking 18 x 22-inch prints. In this striking, domed image of Lake Tahoe, the sun is about to drop behind a range of black mountains while reflecting dramatically on the lake.

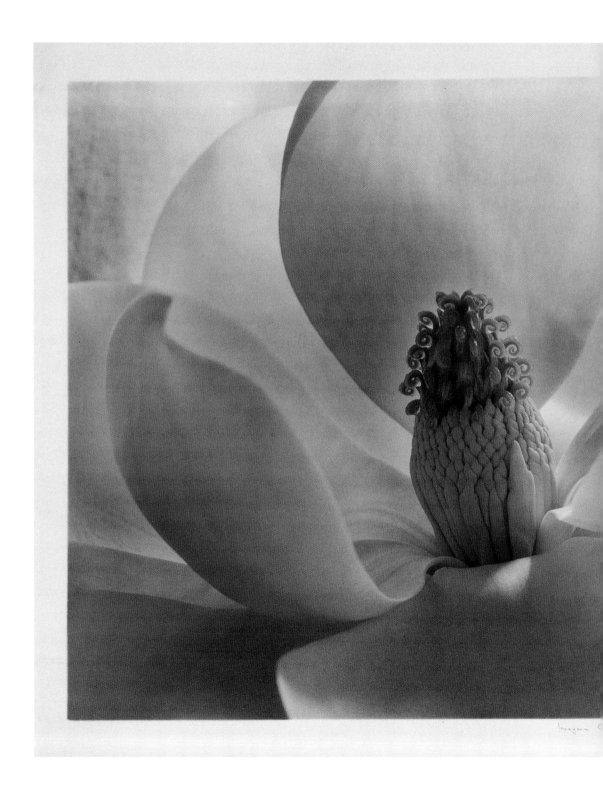

IMOGEN CUNNINGHAM (1883–1976)
Magnolia Blossom
(Formen einer Blume), ca. 1925

Platinum print, 9¼ x 11⅝ in.
(23.6 x 29.5 cm) (image)

Museum purchase, M. H. de Young
Memorial Museum
54042

Imogen Cunningham's interest in people, plants,
objects, and forms was so broad and eclectic that she
claimed to photograph anything that could be
exposed to light. Due to this extraordinary curiosity
and exploring eye she has left a wealth of images,
many of which have become icons of photography.
Her images express a unique marriage of art and
science. Trained as a chemist and an artist, she recog-
nized that she was objectively analytical yet intuitively
expressive, describing her qualifications as: "good
taste, the hand of the skilled mechanic, the eye of an
artist, and the brains of a scientist." From the early
1920s through about 1934 she created many of her
modernist masterpieces of plant forms, as well as
nude studies, industrial landscapes, and experimental
double-exposed portraits. It was during this period
that she produced her well-known series of magnolia
studies in which she rejected the then-popular style
of soft-focused, sentimental photography, creating
precisely focused prints.

Textiles and Costumes

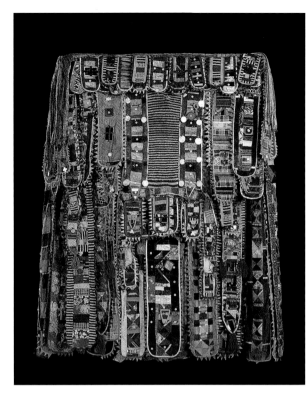

COSTUME FOR EGUNGUN CEREMONY

Yoruba people, Oyo subgroup, Nigeria, ca. 1930–70

Cotton, glass mirrors, metal, shell buttons, wood; patchwork, appliqué, embroidery, looping, applied accessory objects
69 x 50 x 18 in.
(175.3 x 127 x 45.7 cm)

Museum purchase, gift of the Volunteer Council
1998.31

Cloth plays an important role in the world of the Yoruba, whose myths equate nakedness with infancy, insanity, or the lack of social responsibility. By contrast, elaborate dress reflects social power and prestige, and, in the *egungun* (lit. "masquerade") ceremony honoring ancestors and requesting their blessings, it is the major medium through which the masker's transformation is achieved. The *egungun* costume, with its layer upon layer of costly and prestigious fabrics, expresses the wealth and status of a family as well as the power of its ancestors. The design of this costume is closely related to its purpose and the choreography of the performance. Following tradition, the innermost layer closest to the masker's skin is made of an indigo-and-white handwoven fabric that resembles the shroud in which the dead are wrapped for burial. This sacklike layer, along with dense netting over the face, covers the masker so that his identity is completely concealed. On top of this are layers of lappets, decorated with patchwork, sequins, mirrors, buttons, and amulets symbolizing powerful medicines that protect the transformed person from his enemies during the performance. As the masker whirls, the lappets are sent flying, creating a "breeze of blessing."

HEADBAND
Paracas Peninsula, Peru,
300–100 BC

Camelid fiber, feathers;
cross-knit looping
202 x 1⅝ in. (513 x 4.1 cm)

Museum purchase, gift of
the Museum Society Auxiliary
and the Sixth International
Conference on Oriental Carpets
1991.30

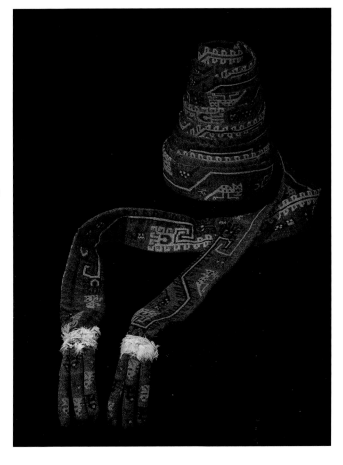

The Paracas culture is known for the intricacy and diversity of its decorated textiles, which many experts regard as the finest made by any pre-Columbian Andean culture. Although more than 2,000 years old, this cross-knit-looped seventeen-foot band, which was worn like a turban, is a striking example. Despite its age, it is in surprisingly good condition, primarily because it was buried on the arid southern coast of Peru, one of the world's driest coastal deserts. In this area prestigious and powerful individuals were wrapped and buried in mummy bundles containing numbers of elaborately patterned, intricately made garments that were meant to accompany the wearer into the next world. The headband's bold, naturalistic imagery includes twenty-five double-headed serpents alternating with fifty small spotted cats. This highly stylized pattern was constructed in a series of interlocking loops in a technique that visually resembles knitting but is far more laborious, as each new loop is inserted with a sewing needle.

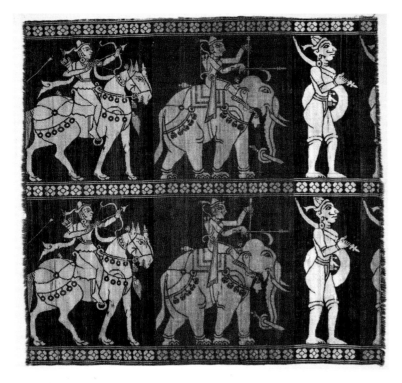

FRAGMENT
North India, 13th–15th century

Silk; weft-faced compound twill (samite)
22 x 22½ in. (55.9 x 57.2 cm)

Gift of George and Marie Hecksher
2000.186.1

This rare panel of woven silk, for centuries the most sought-after and coveted of all textile fibers, depicts a procession of archers astride elephants and horses that are led by marching warriors armed with shields and curved swords. Each register is separated from the next by a continuous band of simple four-petaled rosettes enclosed within thin pairs of guard stripes. Little is known about the origin and development of complex weaves in India; although distinctive textiles such as this require the use of a complex loom, thus far none from such an early date have been discovered on the subcontinent. This unusual figurative martial panel is an example of a design tradition dating to the Indian Sultanate period (13th–16th centuries) that provided a model for Indian weaving for several centuries, but, except for a few examples, has since disappeared.

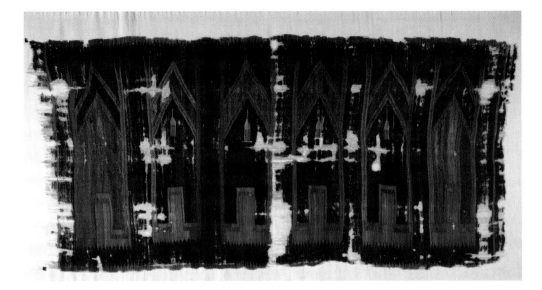

FLOOR COVERING WITH
MULTIPLE NICHES (*SAF KILIM*)
Central Anatolia, Turkey, 17th–18th century

Wool; slit-tapestry weave, 65¾ x 143 in.
(167.5 x 363 cm)

The Caroline and H. McCoy Jones Collection
Gift of Caroline McCoy-Jones
2003.87.5

Kilims, a type of floor covering made in slit-tapestry weave, are recognized as one of the most striking of traditional Anatolian textiles. The composition of this kilim, with its multiple arches, has a long history in Anatolian art. The series of six nichelike forms repeated in just two vivid primary colors, red and blue, epitomizes the superb use of bold design and color for which these kilims are known. Tapestry weave is one of the oldest weaving techniques, dating at least to the fifteenth century BC in Egypt. Although the best-known examples of kilim weaving in Anatolia are from the nineteenth and twentieth centuries, the practice undoubtedly developed much earlier there. Some evidence suggests that slit-tapestry weaving continued uninterrupted for centuries, perhaps even millennia, in this part of the world. This kilim is so sophisticated and shows such mastery of the technique that there is every reason to believe that it dates to a period (seventeenth or eighteenth century) when the kilim tradition was already well established.

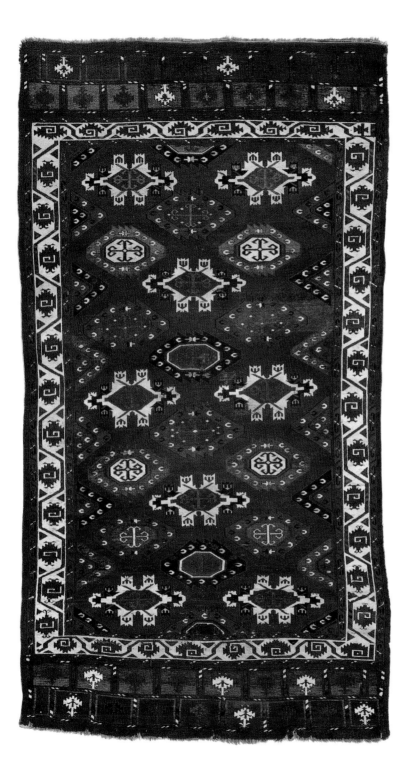

MAIN CARPET

Yomut tribe, Turkmen people, Iran or
Turkmenistan, ca. 1640–80

Wool; knotted pile, 121½ x 65¼ in. (308.6 x 165.7 cm)

Gift of George and Marie Hecksher
2001.173

The art of carpet weaving has a long history in Turkmenistan and neighboring northern
Iran, east of the Caspian Sea. Here handmade Turkmen carpets are woven from pure
wool and have an amazing beauty and durability. Among the Turkmen, rugs of this large
scale are used chiefly on ceremonial or other special occasions by tribal khans or wealthy
urban dwellers. In most main carpets, the design consists of a repeating primary motif
called a *gul*, which some think served as a badge of tribal identification, along with a
usually smaller secondary motif. This rare early example, however, displays a different
kind of pattern, with two different motifs of equal scale. Probably borrowing from
Persian or Caucasian designs, Turkmen weavers made these motifs their own, adapting
the asymmetrical originals and over time transforming them into the symmetrical,
octagon-based patterns for which they had a preference.

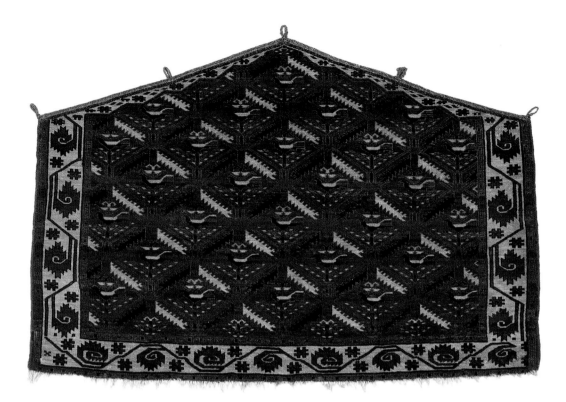

DECORATIVE CAMEL HANGING (*ASMALYK*)

Turkmen people, Tekke subgroup, Iran, late 18th century

Wool; knotted pile, 46 x 30½ in. (116.8 x 77.5 cm)

The Caroline and H. McCoy Jones Collection,
bequest of H. McCoy Jones
1988.11.26

Textiles are the major artistic expression of the Turkmen people of Central Asia and Iran and function as an integral part of daily life. Five-sided weavings like this example were used in pairs to decorate the sides of camels, especially the bride's camel during a wedding procession. Braids hung with multiple tassels originally embellished the sides and lower edge. On other ceremonial or festive occasions *asmalyk* adorned the inside of the owner's tent. The design of this hanging consists of a diamond lattice formed by blue and white serrated leaves, with each compartment containing a stylized bird perched on a branching stem. The origins of this rare design, so distinct from those in other Turkmen weavings, are unknown.

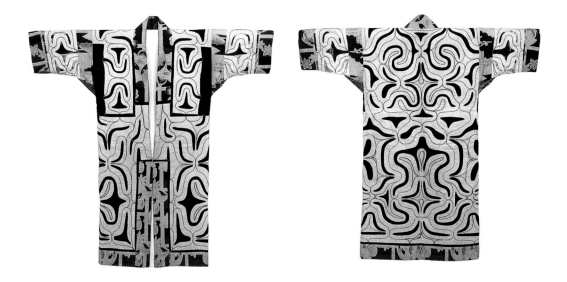

CEREMONIAL ROBE
(*KAPARAMIP*)

Ainu people, Hokkaido Island, Japan, late 19th century

Cotton; commercially woven and printed cloth, appliqué, and embroidery, 54½ x 48 in. (138.4 x 121.9 cm)

Museum purchase, Unrestricted Art Trust Fund
2001.122.3

The indigenous population of Hokkaido, northern-most of Japan's main islands, call themselves *Ainu*, meaning simply "people" or "humans." Physically and linguistically distinct from the ethnic Japanese, their history remains elusive. The earliest known Ainu woven garments are for the most part relatively plain, decorated with only minimal appliqué and embroidery. From the mid-nineteenth century, as a result of growing contact and trade with the ethnic Japanese, the Ainu began employing imported indigo-dyed cotton cloth for their appliqués, which became increasingly larger and more elaborate. Ainu women began to create new abstract graphic designs for embellishing robes, such as this example. The passion to produce these bold designs was inspired by the belief held by the Ainu people that each pattern should differ from the one preceding it.

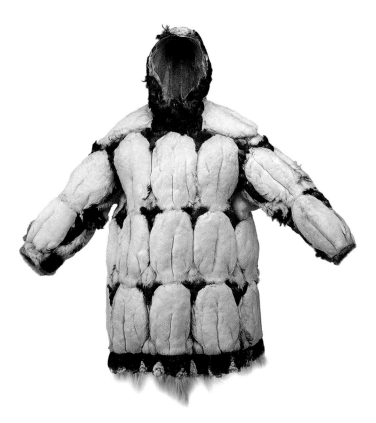

MAN'S PARKA (*ANORAK*)

Inuit, Kings Island,
British Columbia, Canada,
early 20th century

Eider duck breasts, dog (?) hair;
pieced, 46$\frac{7}{16}$ x 26 in.
(118 x 66 cm)

Gift of Mr. P. L. Schoof
47476

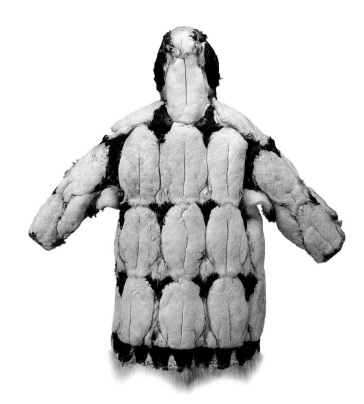

The Inuit of Canada's Arctic live in one of the most extreme climates in the world. Clothing has been one of the keys to their survival. Loose fitting, hooded jackets like this parka were worn by native people from Greenland to Alaska long before contact with Europeans. The main purpose of this garment was to provide warmth for the wearer especially in winter, when temperatures can drop below −50 degrees Fahrenheit and darkness, or near darkness, lasts up to four months. Caribou fur and sealskin provided the most common materials for Inuit parkas, but polar bear and fox fur, ground squirrel pelts, and, as in this case, even the skins of birds were used. Birdskin clothing was light, durable, waterproof, and warm. This parka was constructed by piecing together the abdominal sections of eider ducks. Although European contact brought many changes to Inuit life, the Inuit continued to make their parkas long after the introduction of trade cloth because they were more effective at keeping out cold and dampness than factory-made imports.

CEREMONIAL CLOTH
(*PUA KUMBU*)

Iban people, Sarawak
(western Borneo), Malaysia,
early 20th century

Cotton; warp-faced plain
weave, warp ikat, 100 x 50⅞ in.
(254 x 129.2 cm)

Museum purchase, Unrestricted
Art Acquisition Endowment
Income Fund
2002.108.7

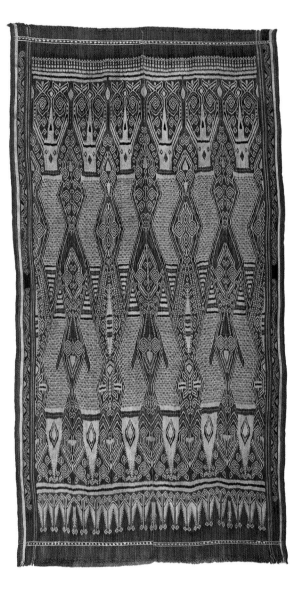

The islands of the Indonesian archi-
pelago have a complex, multilayered
cultural history that is mirrored
in the richness and diversity of the
region's textiles. Some of the most
powerful and enigmatic examples are
the ceremonial cloths woven by
the Iban, the most prominent of the
numerous ethnic groups that inhabit
the rugged interior of Borneo, the
archipelago's largest island. The best-
known Iban textiles are large ceremo-
nial cloths like this one, whose
designs are based on powerful figures
from the spirit world that are
repeated to create a dream-inspired
pattern. As in the finest Iban textiles
the large figurative elements appear to
be in motion. Executed in a resist-
dyeing technique known as warp
ikat, this bold design is extraordinary
in its concept, complexity, and
technical production.

DORCAS MUNROE

Sampler

United States, Massachusetts,
ca. 1800

Linen, silk; embroidery
17½ x 13 in. (44.5 x 33 cm)

Gift of Mrs. Jessie Allard Kline
78.19.1

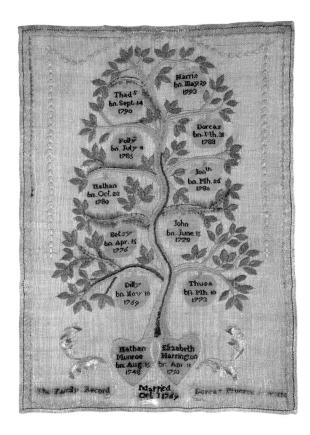

Family record samplers, which can also be viewed as valuable social documents, were popular in America throughout the eighteenth and well into the nineteenth centuries. This charming sampler illustrates the Munroe family record in the form of a fruit-laden tree. It was embroidered by Dorcas Munroe, who records on the sampler that she was born in 1788 and was the eighth child of Nathan Munroe and Elizabeth Harrington of Lexington. This simple form of tree seems to appear primarily in samplers made by girls living in the greater Boston area during the first quarter of the nineteenth century, and it is known that Dorcas Munroe married Leonard Brown of Boston in 1810. Like the majority of New England genealogical samplers, this example records only the embroiderer's parents and siblings.

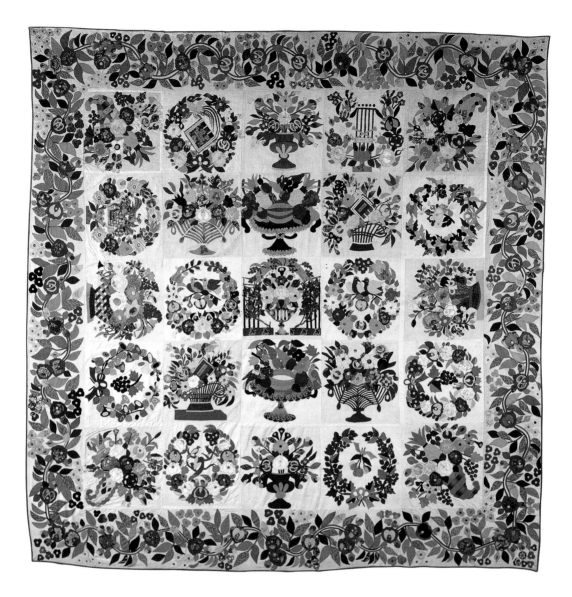

E. McLEAN
Album Quilt Top
Baltimore, Maryland, 1850–60

Cotton, silk; appliqué
113⅜ x 112¾ in. (288 x 286.4 cm)

Gift of Mrs. Nathan Dodge
1990.8

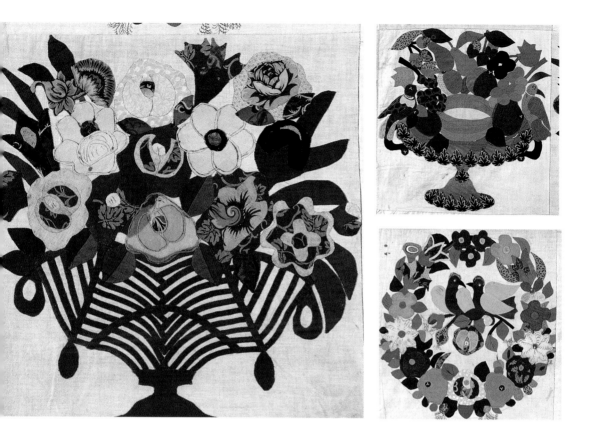

Made to commemorate a special event, such as marriage, birth, leaving a community, or even death, album quilts like this delightful example combined the love of family and friends with the appreciation of beautiful fabrics. In an album quilt each of the blocks is different, and the quilt is signed, although not necessarily in all of the blocks. This type of quilt first appeared in the 1840s, a time of extreme sentimentality brought about in part by the religious awakening that swept the country. During the same period families were uprooted for economic reasons and people were separated from one another, and many women carried quilts composed of blocks containing precious messages from the friends and relatives they had left behind. A mixture of old and new fabrics brought memories of those who made the quilt and whose dresses were used to create it. Album quilts were first made in the Delaware Valley region of Pennsylvania and Maryland, but the trend spread rapidly, and Baltimore, where this colorful quilt was created, became the undisputed center of fine album quilt making.

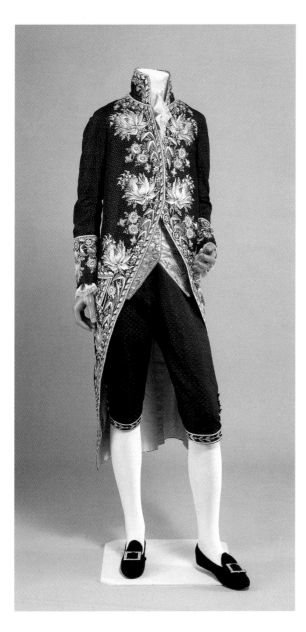

MAN'S COURT SUIT
England, 1780–85

Silk brocade with polychrome
silk embroidery

Museum purchase, Art Trust Fund
1982.4a–b

This suit of rich silk brocade embellished with elaborate floral embroidery in
shaded silks represents late-eighteenth-century men's formal dress at its best. The
coat and breeches may originally have had a matching waistcoat, now lost, and
the suit was probably intended for wear at court. Men's clothing became increas-
ingly plain as the eighteenth century drew to a close, and this type of lavish sur-
face decoration would have been reserved for the most formal of suits.

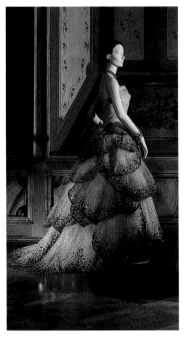

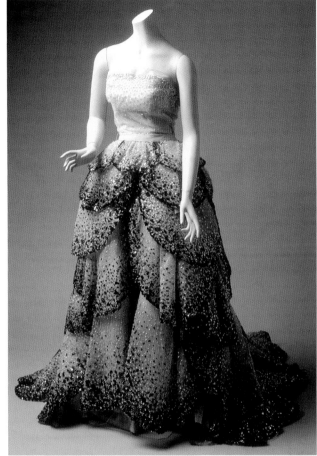

CHRISTIAN DIOR
(1905–1957)
Evening Dress: *Juno*
France, 1949

Silk tulle, silk faille, and sequin
embroidery

Gift of I. Magnin & Company
49.25.2a–b

Christian Dior's first collection under his own name, shown in 1947, was so shockingly luxurious that word of it spread immediately after it was first shown. All credit for reviving French couture after its eclipse during World War II was given to him, despite its resumption two years earlier. Women around the world knew to watch Dior for the proper new hem- or waistline. The peacock, sacred to the Roman goddess Juno, provides the reference for this gown. The embroidery by the house of Rebé is of exceptional richness, allowing the soft tiers of fabric to function as if they were the overlapping feathers of the peacock's tail. Of all Dior's works of the 1940s, *Juno* is an outstanding example of his reliance on opulence to reestablish traditional couture, while expressing his interest in an earlier "golden age" of fashion.

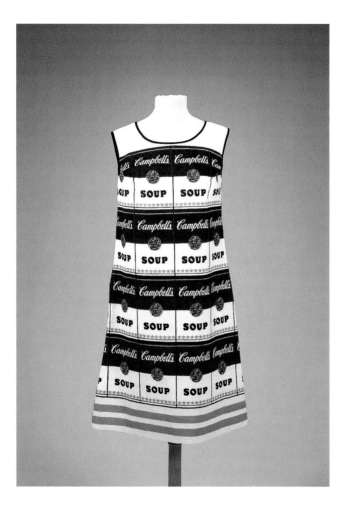

After ANDY WARHOL
(1928–1987)
The Souper Dress, ca. 1967

Cellulose and cotton paper
37 in. (94 cm)

Museum purchase, Barbara
Donohoe Jostes Fund
1998.69

Inspired by the pop art work of Andy Warhol, the *Souper Dress* is an icon of the intersection of art, style, and commerce of the 1960s. Printed with repeating images of Campbell's soup labels, the dress is labeled: *The Souper Dress/no Cleaning—no Washing—It's Carefree/Fire Resistant Unless Washed Or Cleaned.* Warhol, who began his career as a fashion illustrator, had been painting Campbell's soup cans since 1962, and his work inspired the Campbell's company to create this mass-produced dress as a marketing tool that would capitalize on both the publicity generated by the artist's groundbreaking work and the rage for stylish, disposable paper clothing. In pop art the appropriation of advertising icons led to a synthesis of word and image, art and the everyday.

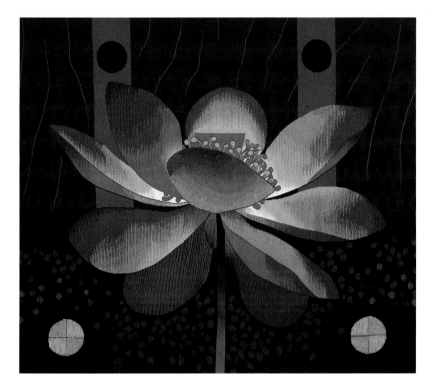

MARK ADAMS (b. 1925)
Lotus Sumatra
San Francisco, California, 1989

Cotton, wool; tapestry weave
80 x 92 in. (203.2 x 233.7 cm)

Gift of Mark Adams and Beth
van Hoesen honoring Anna Bennett,
her husband Ralph, and the
volunteers who saved the museums'
tapestry collection
1992.34

A large, fully opened lotus blossom in shades of intense pink is brilliantly illuminated against a red, patterned background in this tapestry by Mark Adams. The lotus, a universal symbol of Buddhism, rises up from the dark mud to unfold in the light. The particular lotus depicted here grew on the shores of Lake Toba, Sumatra, in a village of the Batak people. Adams's approach to tapestry design, as illustrated by *Lotus*, reveals his masterful technique, which utilizes the unique qualities of the tapestry medium rather than merely imitating a painting in wool. Adams is concerned with pattern, but his schemes evolve from the observation of nature. He expresses the forces of nature and the cosmos in an abstract style with images that appeal directly to the eye and the spirit.

Published on the occasion of the re-opening of the
de Young in Golden Gate Park, San Francisco, California,
October 2005

Published with the assistance of the Ednah Root Foundation

Published in association with Scala Publishers, London,
by the Fine Arts Museums of San Francisco:
Ann Heath Karlstrom, Director of Publications
and Graphic Design
Elisa Urbanelli, Managing Editor

Text and Photography Copyright © 2005 Fine Arts
Museums of San Francisco
This edition Copyright © 2005 Scala Publishers Limited

British Library Cataloguing in Publication Data.
A catalogue record for this book is available from
the British Library.
Library of Congress Control Number: 2005931031

First published in 2005 by
Scala Publishers Limited
Northburgh House
10 Northburgh Street
London EC1V 0AT
United Kingdom

Distributed outside of the Fine Arts Museums of
San Francisco in the North American booktrade by
Antique Collector's Club Limited
Eastworks
116 Pleasant Street, Suite #60B
Easthampton, MA 01027
United States of America

ISBN 1 85759 406 1

Edited by Audrey Walen
Designed by Pooja Bakri
Printed in Singapore

10 9 8 7 6 5 4 3 2 1

Page 2: Frederic Edwin Church, *Rainy Season in the Tropics*
[detail], 1866 (see pages 72–73)

Page 4: Richard Diebenkorn, *Green* [detail], 1986
(see page 131)